joy of

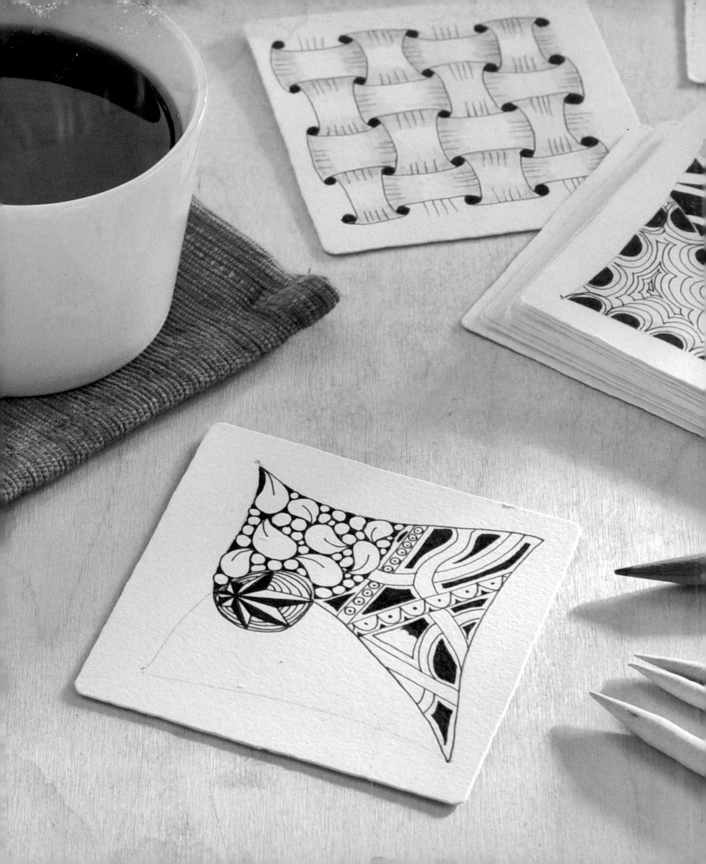

joy of zentangle®

Drawing Your Way to Increased
Creativity, Focus, and Well-Being

FEATURING CONTRIBUTING ARTISTS:

Suzanne McNeill, CZT, Sandy Steen Bartholomew, CZT,
and Marie Browning, CZT

Design
Originals

an Imprint of Fox Chapel Publishing
www.d-originals.com

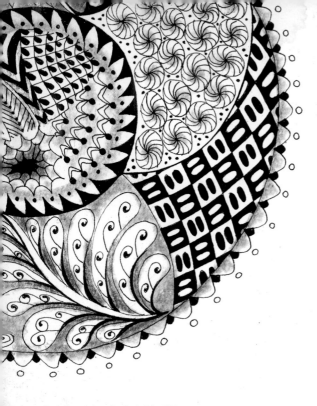

Acknowledgments

Special thanks to Cindy Fahs, CZT, for providing expert advice and invaluable feedback during the development and creation of this title. Your efforts were truly above and beyond—thank you!

Special thanks to Meredith L. Yuhas, PhD, LPC, NCC, ACS, CZT, for providing material to help develop the first chapter of this book.

Cover Zentangle art by Cindy Fahs, CZT.

Thanks to Bette Abdu, CZT, Michele Beauchamp, CZT, Maya Bhatt-Hardcastle, CZT, Mandy Boukus, Margaret Bremner, CZT, Marie Browning, CZT, Jill Buckley, Sandra Chatelain, CZT, Linda Cobb, CZT, Kristi Parker Van Doren, Marta Drennon, CZT, Gail Ellspermann, Cindy Fahs, CZT, Tina Festa, CZT, Carol Bailey Floyd, CZT, Lois Henderson, Toni Henneman, CZT, Sarah Higgins, CZT, Sue Jacobs, CZT, Kathy Jones, Karen Kathryn Keefe, CZT, Debbi Lagan, Lynda Leeper, Cris Letourneau, CZT, Judith McCabe, MFA, CZT, Brinn McFetridge, CZT, Sue Needle, Sarah S. Nestheide, Carole Ohl, CZT, Jennifer Van Pelt, Kathy S. Redmond, CZT, C. C. Sadler, CZT, MaryAnn Scheblein-Dawson, CZT, Peggy Shafer, Cindy Shepard, CZT, Joanna Campbell Slan, Lisa Stearns, Sandra K. Strait, Dedra True-Scheib, CZT, Angie Vangalis, CZT, J. Michelle Watts, CZT, SherRee Coffman West, John Yanchek, Karenann Young, Melissa Younger, Meredith L. Yuhas, PhD, LPC, NCC, ACS, CZT, and Renee Zarate, CZT, for their generous contributions to this book.

ISBN 978-1-57421-427-7

Library of Congress Cataloging-in-Publication Data

McNeill, Suzanne.
 Joy of Zentangle / Suzanne McNeill and Sandy Steen Bartholomew.
 pages cm
 Includes index.
 Summary: "Zentangle® is an easy-to-learn method of pattern drawing that reduces stress while promoting creativity. This book will introduce readers to the basic theory of Zentangle and provide instructions for drawing over 100 tangle patterns from such Certified Zentangle Teachers as Suzanne McNeill, Sandy Steen Bartholomew, and Marie Browning. This beautiful book is filled with examples of Zentangle drawings as well as other art projects and compelling stories from those who have improved their well-being through Zentangle"-- Provided by publisher.
 ISBN 978-1-57421-427-7 (pbk.)
 1. Drawing--Technique. 2. Drawing--Psychological aspects. I. Bartholomew, Sandy Steen. II. Title.
 NC730.M34 2012
 741.201'9--dc23
 2012026301

Joy of Zentangle is a collection of new and previously published material. All opinions expressed in this work do not necessarily reflect the opinions or philosophies of the contributing artists. Portions of this book have been reproduced from: *Zentangle Basics, Zentangle 2, Zentangle 3, Zentangle 4, Zentangle 5, Zentangle 6, Zentangle 7, Zentangle 8, Zen Mandalas, Inspired by Zentangle Fabric Arts Quilting Embroidery*, all by Suzanne McNeill, CZT; *Totally Tangled, Yoga for Your Brain*®, and *Zentangle for Kidz*, by Sandy Steen Bartholomew, CZT; and *Time to Tangle with Colors*, by Marie Browning, CZT.

"Zentangle", the red square, and "Anything is possible, one stroke at a time" are registered trademarks of Zentangle, Inc. Zentangle's teaching method is patent pending and is used by permission. You'll find wonderful resources, a list of Certified Zentangle Teachers (CZTs), workshops, a fabulous gallery of inspiring projects, supplies, kits, and tiles at *www.zentangle.com*.

Printed in the United States of America
First printing

Bring the Joy of Zentangle® into Your Life

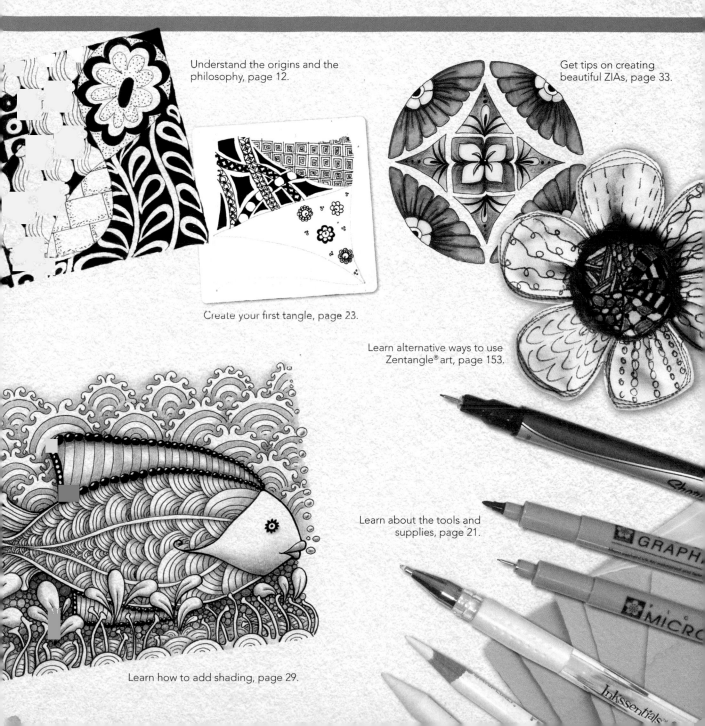

Understand the origins and the philosophy, page 12.

Get tips on creating beautiful ZIAs, page 33.

Create your first tangle, page 23.

Learn alternative ways to use Zentangle® art, page 153.

Learn about the tools and supplies, page 21.

Learn how to add shading, page 29.

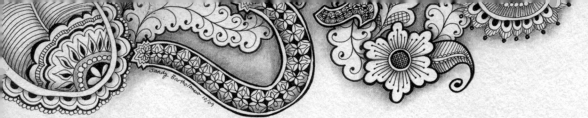

About the Contributing Artists

Suzanne McNeill

Suzanne is often known as "the Trendsetter" of arts and crafts. Dedicated to hands-on creativity, she constantly tests, experiments, and invents something new and fun.

Suzanne has been the woman behind Design Originals, a publishing company dedicated to all things fun and creative. She is a designer, artist, columnist, TV personality, publisher, art instructor, author, and lover of everything hands-on. Visit her blog to see events, books, and a 'Zentangle of the Week.' She also shares her techniques and ideas in YouTube demos. You can contact Suzanne at *suzannebmcneill@hotmail.com* or visit her online at *www.sparksstudio.snappages.com* or *blog.suzannemcneill.com*.

Sandy Steen Bartholomew

Sandy Steen Bartholomew is an author, illustrator, mixed-media artist, and a Certified Zentangle Teacher. She ran a creativity general store (Wingdoodle), a mini-gallery (The Beehive), and a rubber stamp company (Bartholomew's Ink). Currently, she runs an art studio (Beez Ink), a teaching studio (The Belfry), and an Etsy shop (Bumblebat). Her life looks like a Zentangle! She is inspired by juicy jewel-tones and rusty-crusty, peeling, earth-covered things. Magic and mystery, bits and pieces, and weird little creatures. If it sits still, she'll paint it.

Sandy lives with her two kids, and a cat in their colorful, mixed-media house in Warner, New Hampshire—a town full of introverted artists she has never met. Visit Sandy's website at *www.sandysteenbartholomew.com*.

Marie Browning

Marie Browning doesn't recall how early in life her passion for crafting began, but she knows it is definitely genetic! Her family, full of quilters, woodworkers, and artists, helped her develop a respect for human creativity. She finds the more she progresses along the technological path of today's computerized society, the more she values those honored skills of the imagination worked out through human hands in the form of arts and crafts. You can contact Marie and view more of her work at *www.mariebrowning.com*.

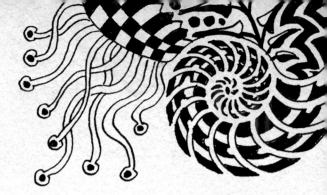

Contents

> ## Anything is possible, one stroke at a time.™
>
> —Rick Roberts and Maria Thomas

This book will change your life.

If you try Zentangle® for even a few minutes, you'll find yourself getting calmer and more focused. You'll feel more like yourself when you are at your best. Do a few more Zentangle pieces and you'll begin to notice the world around you in a different way—it will seem brighter, more colorful, more in focus. You'll see patterns and beauty everywhere you go. You'll find yourself becoming less stressed, judge yourself and others less, and feel happier and more content.

I know these are big claims for such a simple, humble action as tangling, but they are true. You can prove it to yourself very simply in less than an hour by following the instructions for creating your first Zentangle in Chapter 2.

Dear Reader:

Within the pages of *Joy of Zentangle*, you'll learn more about the how and why of the Zentangle® method. Your guides will be the top authors on the subject—Suzanne McNeill, Sandy Steen Bartholomew, and Marie Browning, all CZTs (Certified Zentangle Teachers). Other CZT's from around the world share their artwork and inspirational stories on these pages as well.

To understand the phenomenon of the Zentangle method, it is also important to understand the motivation and personalities of its creators, Rick Roberts and Maria Thomas. Eager to meet them in person after reading the many Design Originals Zentangle titles and having created a few Zentangle pieces on my own, I wasn't sure what to expect. I had "native habitat" was a heady experience—something guaranteed to stimulate one's creativity. Through our conversations it became clear to me that helping people grow and develop their own inner talents is Rick and Maria's deepest heartfelt wish and purpose.

Both their concept of "tangling" and the way Rick and Maria have chosen to run their business is so simple and unusual that it took some getting used to before I understood what it's all about.

The creative inspiration behind what is fast becoming a worldwide phenomenon of creative expression and personal freedom started with the simple wish to help others discover their inner artist. Maria is an accomplished artist. Her calligraphy has

> ### Simplicity is the ultimate sophistication.
> —Leonardo da Vinci

found my limited time spent drawing on the Zentangle tiles to be very relaxing, but also more than a bit confusing. After our meeting, it become clear that the confusion was of my own making—I'd been too focused on mimicking a certain design rather than trusting the Zentangle process.

The hours Rick and Maria graciously spent with me went by quickly. Their lovely home is filled with beautiful art of their own making, as well as antiques and artwork by others. My time with them in their own been commissioned by top institutions, art collectors, and celebrities. For several years, Rick Roberts handcrafted Native American-style flutes out of gorgeous woods. Later, before Zentangle, Rick and Maria had a successful series of booths and exhibitions at art and craft shows where their work was well received. Maria's hand lettering in flowing script on her artwork attracted crowds of people to their booth. Customers loved watching her work.

> That's been one of my mantras—focus and simplicity. Simple can be harder than complex: You have to work hard to get your thinking clean to make it simple. But it's worth it in the end because once you get there, you can move mountains.
>
> —Steve Jobs

The pair noticed how often people would say: I wish I could do that, but I'm not creative at all; I can't draw; or I could never do that.

When Rick and Maria came up with the idea that became Zentangle, they realized this could be a way to address all those excuses they heard from these wonderful people.

I don't have the time to be an artist.

I don't have the money to take up art.

I don't have space to set up a studio.

Like all good ideas, it can seem obvious after the fact.

Feel like you will never have the time to experiment with drawing? A Zentangle tile can typically be completed within fifteen minutes.

Is money tight? All you need to tangle is a pencil, Sakura pen, and Zentangle tiles. These essentials can be purchased for less than $10. Each blank tile is less than $1.

No space or waiting to build that dream studio? Awakening your creative spirit is too important to put off until some day that may never come. Zentangle art can be created on a bus, airplane, or subway train, or in a waiting room—almost anywhere—even the palm of your hand.

Writing about being creative and making art is always difficult, and Zentangle is particularly difficult to explain. The best analogy I've found yet is the title of Sandy Steen Bartholomew's bestselling book *Yoga for Your Brain®*. Zentangle delivers that same sense of thriving and health that yoga can to those who practice it—a wonderful release from tension and stress, and increased mental clarity. And even better, with Zentangle you have something tangible when you're done—a piece of artwork that captures a piece of you at a particular moment in time, something you can give away or share with others.

Enough said. Now it is time for you to jump in to learn and experience Zentangle for yourself!

I'd love to hear your stories and experiences as you discover your own "joy of Zentangle." Please write or email me anytime.

Alan

Alan Giagnocavo
Publisher
Fox Chapel Publishing/Design Originals
1970 Broad Street
East Petersburg, PA 17520
publisher@FoxChapelPublishing.com

Zentangle Resources

Before you go further, here is some Zentangle® information in which you might be interested.

The CZT Network

There are more than 400 CZTs (Certified Zentangle Teachers) worldwide, in more than 10 countries, and in 44 states/districts in the United States. This CZT network is constantly growing and offers an excellent way to connect with the Zentangle method for the first time if you are curious, have questions, or simply want to have a conversation with someone who has firsthand experience with the art form. With their vast and growing numbers, there is likely a CZT in your area. Each of these individuals has been taught the Zentangle method by creators Rick Roberts and Maria Thomas and are excited to share their knowledge with others.

Locating a CZT is simple. The Zentangle website (*www.zentangle.com*) contains a complete list of all CZTs with their contact information, so reaching out to a CZT is as simple as clicking a link.

If you are interested in becoming a CZT yourself, the Zentangle website has all the information you need to take the first step. CZT seminars are four days long, and are held in Providence, Rhode Island. The seminar is fun, powerful, and enriching, and is sure to give you an experience you will never forget. More importantly, it will give you the greatest understanding of the Zentangle method possible, as you learn from its creators.

Using Zentangle

After you discover the Zentangle method, you may find you want to share the art form with others. Your enthusiasm and willingness to share are encouraged; however, please keep the following in mind:

- It's understandable that you might wish to share the Zentangle method with family or friends. It's an exciting thing, and everyone who wants to learn the method should be able to do so! However, please make sure any family/friends you are teaching understand they are learning the Zentangle method. Use Zentangle language, such as tile, string, and tangle, when teaching. Please do not say you are a CZT if you are not. If you are interested in becoming a CZT, please visit the Zentangle website for information.
- You may use Zentangle patterns and/or their names to create Zentangle art or ZIAs (Zentangle-Inspired Art) for yourself or for commercial use. You may also choose to copyright this artwork.
- If you are creating and selling Zentangle art or ZIAs, please include "®" after the word "Zentangle" for traditional Zentangle art, and "Inspired by the Zentangle® method of pattern drawing" on ZIAs. If possible, please direct customers to *www.zentangle.com* for more information. Please also ensure customers are aware that your work is your own and not created by Zentangle, Inc.
- Please contact Rick Roberts and Maria Thomas for use of the Zentangle name and logo.

Thank you for your understanding, and enjoy creating with the Zentangle method!

What is Zentangle?

The Zentangle method, created by Rick Roberts and Maria Thomas, is an easy-to-learn, relaxing, and fun way to create beautiful images by drawing structured patterns. Rick and Maria's combined life experiences opened the door for the creation of this method. Rick spent many years living as a monk practicing meditation and other spiritual exercises, and Maria has incredible artistic talent, working as a botanical art illustrator and lettering artist. Rick noticed that when Maria was making simple, repetitive strokes inside a large illuminaed letter, her mood and demeanor changed, and she became entirely focused on what she was doing. When Rick asked Maria to explain what she was experiencing at those times, her description matched that of a state of meditation. The pair decided to develop a method that would allow anyone to feel the peace and relaxation Maria had experienced, all while creating a beautiful and meaningful piece of art. The Zentangle method has grown to become a worldwide phenomenon, attracting individuals from all walks of life. Rick and Maria now operate a Zentangle website (*www.zentangle.com*), where they provide information on the subject, as well as a gallery, and sell top-notch supplies for those who want to tangle. The Zentangle blog (*www.zentangle.blogspot.com*) offers inspiration and messages from Rick and Maria. The pair have taught nine Certified Zentangle Teacher seminars in Providence, Rhode Island.

No artistic talent required. You don't have to be an artist or have artistic talent to experience and create Zentangle art. Rick and Maria's trademark tagline, "Anything is possible one stroke at a time."™ sums up the entire philosophy behind the Zentangle method. While many of the patterns or tangles might look complicated at first glance, once they are deconstructed down to their simplest form, they are revealed as a series of lines, dots, and shapes repeated in a pattern. The tangles are very representative of life's problems—if you break a problem down into little pieces, it doesn't seem as overwhelming, and it is much easier to overcome.

Simple, portable tools. Zentangle art only requires a black pen, white paper, and a pencil. Note that there's no mention of an eraser. Just like life's mistakes cannot be erased, misplaced marks on a Zentangle tile cannot be erased. It is up to you to own the "mistake" and figure out how to incorporate it into the tangle design. You might have to alter the pattern or just leave the "mistake" as it is, but you can't erase it. Because there are so few of them, Zentangle supplies can easily travel with you so you can tangle anywhere. You can tangle on coasters in a restaurant, on napkins, on the backs of business cards, and even on church bulletins. Anytime you feel the need to relax and focus, no matter where you are, you can turn to the Zentangle method.

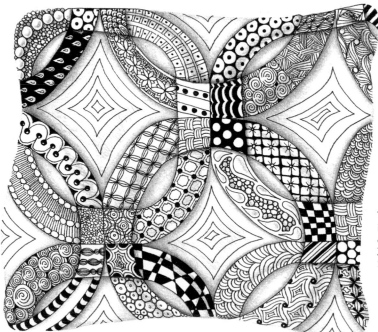

Traditional Zentangle art is done in black and white on a square tile of paper. Zentangle art by Sandy Steen Bartholomew, CZT.

Purposeful. Zentangle art has a specific, important purpose. Because of this, each line or mark made in a tangle should be given thoughtful attention and be made with care. Unlike doodling, where marks are made randomly, with the Zentangle method, every pen stroke is very deliberate and intentional. Doodling is mindless, and the end result is not always a piece of art. The Zentangle method is mindful and the end result is *always* a piece of art!

New perspective. Once you start tangling, you will look at the world around you differently. You will see patterns everywhere—on fabric, in architecture, and in nature. You will find yourself appreciating the simplicity or complexity of your surroundings.

Individualistic. Just as no two people are the same, no two tangles are the same. A Zentangle art piece is just as unique and distinct as the person who created it. You should not worry about imitating another individual's Zentangle art, but always strive to give each Zentangle piece a bit of your own style and personality. No Zentangle creation is ever wrong, and every tangle pictured in this book is merely a suggestion or starting point. You can adapt and change any tangle to make it your own.

Ritualistic. Humans are creatures of habit, or rituals; we all like some sort of structure in our lives. Just think of your morning routine and what happens if it is disrupted—your entire day can be ruined. The Zentangle ceremony is a ritual that can provide the structure you desire. Each step is deliberate and relaxing at the same time and leads naturally into the next one. See page 23 for the steps of the Zentangle ceremony.

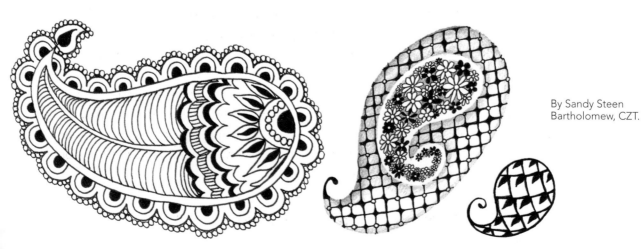

By Sandy Steen Bartholomew, CZT.

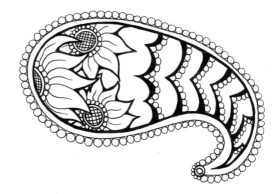

No required outcome. Just as we don't always know where our lives are going and the circumstances we will face, Zentangle art should not be planned or have a blueprint. Because you are not required to follow a plan or stick to a specific path, you can enjoy the process of tangling without having to worry about the outcome. The Zentangle ceremony is loosely structured with repetitive, simple steps designed to assist you in relaxing and focusing. At times, these steps can even be inspiring. The result of tangling—the beautiful artwork—is just an added bonus and a delightful surprise when you are finished.

Simplicity. While it seems you could use a pen of any color to create a Zentangle art piece, traditional Zentangle pieces are created using only black ink on white paper, with gray pencil shading. By keeping yourself to these options, you eliminate decisions about the colors you should use or when to switch to a different color. The Zentangle method is designed to keep your mind from engaging in left-brain activities, like decision-making and analysis, as much as possible. When you start thinking too much about what your next step should be, you lose the relaxed, meditative state the Zentangle method is meant to produce, and anxiety can creep in. By limiting the number of decisions you need to make, you keep yourself calm, focused, and relaxed.

Abstract. By design, Zentangle art is not made to look like anything. It's abstract, without a distinct shape or a top and bottom. Because a Zentangle piece is not required to resemble anything else, while you are tangling, you can focus on each individual stroke of your pen and get lost in the repeating pattern instead of trying to force the tangles to fit a specific shape. This is an important and unique aspect of the Zentangle method. Zentangle is one of the few art forms in which you intentionally refrain from planning the look and design of the finished piece. Without a specific expectation in mind, you are free to enjoy the process rather than having to worry about whether your piece matches its intended design.

No right or wrong. There is no failure with the Zentangle method. Your Zentangle art doesn't have to and shouldn't look exactly like anyone else's. And, because there is no pre-planning and no mistakes, no one can tell you the end result is wrong.

> **tip** When creating, you are "tangling." (Zentangle is not a verb.)

What are the Benefits and Uses?

Countless experts in various professions, including psychology, education, and counseling, are in the process of exploring the benefits and uses of the Zentangle method and the meditative-like state it is capable of producing. Many have found Zentangle to be a wonderful way for individuals to cope with trauma or grief, or as a way to build self-confidence and promote self-expression. As with many processes of healing and self-exploration, each individual's experience with the Zentangle method is unique, and the benefits that come from Zentangle are specific to each person who uses it.

Director of the Counseling and Wellness Center at the University of Saint Joseph in West Hartford, Connecticut, Dr. Meredith Yuhas has experienced the benefits of the Zentangle method personally, and has seen its impact in the lives of her clients. For Dr. Yuhas, Zentangle is an example of mindful meditation.

Mindfulness can be described as an awareness of yourself in the present, including an awareness of your body, your mind, your thoughts, and your feelings. When you are mindful, you recognize what you are thinking and feeling, but are not compelled to judge these thoughts or feelings as good or bad, right or wrong. The practice of mindful meditation is meant to help you reach this state of awareness. Unlike other forms of meditation, mindful meditation does not ask you to change

yourself or your actions, only to be aware of yourself and the actions of your body and mind. Mindful meditation often includes focusing on your senses—the feeling of your body in a chair, the sounds of the world around you—your breathing, and your thoughts. You are not asked to change these things, only to recognize that they are there. If your mind wanders during mindful meditation, it is not a bad thing; it is natural for the mind to wander. Mindful meditation only asks that you recognize your mind has shifted to focus on something else during your meditation.

Research into mindfulness and its potential applications in medicine have yielded study after study that suggest mindfulness is an excellent tool to help patients cope with grief, stress, chronic pain and disease, depression, and to improve their general well-being. Dr. Jon Kabat-Zinn, one of the world's leading researchers on mindfulness and its ability to affect and improve our lives, founded the Center for Mindfulness in Medicine, Health Care, and Society in 1995. The Center for Mindfulness is a revolutionary medical and research facility that pairs mindfulness and similar mind-body techniques with standard medical practices to give patients a completely unique and empowering healing experience.

In his book *Wherever You Go, There You Are*, Dr. Kabat-Zinn wrote about mindful meditation, "Imagine how it might feel to

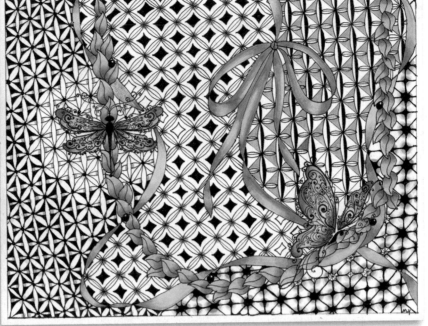

Have it All
ZIA by Dr.
Meredith Yuhas.

suspend all your judging and instead to let each moment be just as it is, without attempting to evaluate it as 'good' or 'bad.' This would be a true stillness, a true liberation. Meditation means cultivating a non-judging attitude toward what comes up in the mind, come what may."

For Dr. Yuhas, mindfulness is a crucial part of everyday life that has been slowly slipping away.

"I find, in this fast-paced age of technology, the need for mindfulness is critical. Mindfulness used to be integrated into our lives automatically. People had to wait for almost everything—for information, to talk to someone, for their television show to come on. Waiting and limited access provided us the moments to be present, mindful, and quiet. There wasn't instant satisfaction and constant access through

technology. Today, the expectation of the pace of life doesn't automatically allow most of us to practice patience, calm, or uninterrupted focus. We have to choose and deliberately find ways to be quiet."

Zentangle, she believes, is the perfect way to practice and develop the skills necessary to achieve mindfulness.

Dr. Yuhas first encountered Zentangle after the death of her father. The first day of her summer break from the University of Saint Joseph, she saw an advertisement for a Zentangle class at her local scrapbooking store and signed up to participate. Zentangle turned out to be exactly what Dr. Yuhas needed to process the trauma of her father's death, and also opened doors to a new area of research. During her first Zentangle class, Yuhas experienced a feeling of calm focus while she was

drawing, and came to recognize it as a state of mindfulness.

"I wanted to stand up and shout it out. I looked around the room, wanting to share my good news, only to see everyone with their heads buried in their tiles. I could barely contain my excitement, as I felt I had found the most extraordinary of mindfulness activities," Yuhas said.

Dr. Yuhas' background in Cognitive Behavioral Therapy (CBT) and Dialectical Behavior Therapy (DBT), as well as her personal practice of yoga, made it apparent to her that the Zentangle process contained all the components of a mindfulness activity. Spurred on by this revelation, Yuhas sought to learn more and to share Zentangle with her colleagues and clients. She practiced Zentangle enthusiastically for months and became a Certified Zentangle Teacher (CZT). During her CZT seminar, Yuhas was able to share her experience with Rick Roberts, one of the co-creators of the Zentangle method, and express her strong desire to provide her profession with the necessary empirical support to use Zentangle in a clinical setting. Yuhas' desire would quickly become reality; she conducted two studies to collect empirical data about the use of the Zentangle method and will soon complete her third. The studies are aimed at establishing Zentangle as a mindfulness activity and understanding its perceived positive effects on the individuals practicing the Zentangle method.

In addition to her research studies, after becoming a CZT, Dr. Yuhas organized and taught Zentangle outreach workshops for family, friends, faculty, staff, and students on the University of Saint Joseph campus. After six months of these workshops, Yuhas estimates that she taught approximately five hundred people the Zentangle method. Yuhas also introduced Zentangle to many of her clients at the University's Counseling and Wellness Center. She noted that individuals already exposed to aspects of CBT and DBT interventions easily integrated Zentangle into their methods of coping. In fact, Zentangle appeared to be as effective as any other coping strategy for those who practiced it. Yuhas saw that Zentangle helped each client individually, with some common positive effects, and appeared to produce the same positive effects as most mindful meditation practices.

Dr. Yuhas feels the Zentangle method is an excellent technique for those in her profession, stating, "Zentangle can provide many professionals with an additional tool to help their clients/students reach a place of inner calm, task focus, and peace for the time they are practicing."

In addition to noticing Zentangle's positive effects on her clients, Dr. Yuhas saw that it produced these effects with little training, cost, and practice. Essentially, she found Zentangle produced positive results easily and almost instantly.

Simplicity Zentangle art by Dr. Meredith Yuhas.

The benefits of Zentangle are not limited to those affected by a specific condition or disorder. Acquiring a sense of peace and calm is a life skill that can benefit anyone. It is a healthy practice that fits right in with other elements of a healthy lifestyle, like eating right or exercising regularly. Zentangle is a fun activity that can:

- increase creativity and problem solving
- create a sense of peace and calm
- lower stress
- quiet the mind
- produce a sense of accomplishment, satisfaction, and confidence
- increase focus and concentration
- help individuals stay in the present moment
- help individuals feel purposeful
- provide a healthy distraction

In addition to these benefits, some who practice the Zentangle method have noticed improved hand-eye coordination, memory, pain management, sleep, and lower blood pressure.

As with all types of mindful meditation and stress management activities, Zentangle provides one more option for better well-being. It might not be right for everyone, but for those who practice it, Zentangle can be a satisfying, healthy stress-management activity from which they will experience many of the positive effects of a mindful meditation activity.

"Zentangle provides an easy, affordable, and appealing way to develop mindfulness and reap the healthy rewards. The ability to sit on a pillow and meditate is difficult, but almost everyone can hold a pen and draw," says Dr. Yuhas.

The best way to discover how Zentangle can benefit you is to try it yourself. Take a few moments of your time to create your first Zentangle and be *mindful* of your thoughts and feelings as you create it. You might be surprised by the results!

Zentangle Basics

The Zentangle method is meant to be relaxing, not complicated. It frees your mind instead of asking you to intently focus or concentrate on a complex task. Because of this, the basics of Zentangle are truly—basic. In fact, starting your first Zentangle piece is as easy as one, two, three: dots, connect, string. As you get started, keep these things in mind:

1. There is no up or down. The beauty of a completed Zentangle creation is that it can be viewed from any angle; it has no top or bottom. This means you can work on a Zentangle tile from any direction or rotate it as you work. Let go of the idea that your tile must face a certain way.

2. There is no right or wrong. Five people can draw the same tangle, and the results will be somewhat different. Some might draw with straight lines, and others with swirls or curves. Some will fill in different areas than others. Some will add shading. There is no wrong way to draw a tangle. In fact, if you produce a tangle that's identical to one in this book, you probably haven't put enough of yourself into it. Make each tangle your own.

3. There are no mistakes. Zentangle art is done in pen, without erasers or Wite-Out®, because in Zentangle, there are no mistakes. If you place a line somewhere you don't want it in a Zentangle piece, it's up to you to determine how to incorporate it into the design. Just like you can't erase things you've done in life, you can't erase what you've done in Zentangle art.

Remember these things as you work on your first Zentangle, and you will be amazed by the results!

Zentangle Tools

To complete any Zentangle creation, you only need three tools: a pencil, a pen, and a piece of paper. While you can use any type of pencil, pen, or paper you desire, those listed are recommended specifically for Zentangle. The tools list has also been expanded with some extras that might come in handy as you continue on your Zentangle journey.

The essentials

Pencil. Any No. 2 pencil will do. Find one without an eraser so you won't be tempted to "fix" your art.

Pigma® Micron 01 black pen. With pigmented, non-bleeding, archival ink, these 0.25mm pens are a dream for drawing.

Zentangle tiles. These 3½" (89mm)-square tiles are made from fine Italian paper. Once you tangle on these, you'll never be happy with cardstock (or notepaper!) again (visit *www.zentangle.com* to purchase tiles). Watercolor hp paper can make a nice surface to tangle on, too, but be sure to cut it down to a manageable and portable size.

> **tip**
>
> When first learning the Zentangle method, keep it simple, and stick to the essential tools. The point is to focus your mind on the lines and patterns and not worry about what pen to use.

Zentangle extras

Storage box. A simple box with a lid will keep your tools and tiles safe in your purse or pocket. A little cardboard jewelry box is a perfect option.

Pencil sharpener. No explanation needed here. If you want, purchase an electric one for your home and a small handheld one for tangling on the road.

Graphic 1 pen. These pens have the same ink as Micron pens, but with a bullet-shaped tip that's great for making wide lines and filling in large areas of your Zentangle tile with black.

Pigma® Micron 01 pens in colors. A red Micron pen is perfect for use on trading cards or any time you want to show Zentangle steps. A brown or sepia Micron pen works beautifully for Mehndi designs and on brown paper, too.

White colored pencil. This is great for getting a Zentangle piece started on dark paper.

White gel pen. This allows you to create beautiful Zentangle art on black paper.

Blending stumps. Use these to smudge your pencil lines when shading a Zentangle piece. You could use your finger, but these are neater, more precise, and come in different varieties, sizes, and shapes.

Tangle ATCs (Artist Trading Cards). These blank trading cards are a way to keep track of tangles. They are the size of baseball cards and fit into the collector sleeves that go into a three-ring binder. These are perfect for keeping patterns organized, and they make preparing for a class or Zentangle club meeting a breeze. A journal or notebook works well, too.

Tangling for Kids

Most younger children find it easier to draw big while they are still developing dexterity. Try starting young ones off with a black Sakura Sensei pen and a larger 4½" (114mm) square tile similar to what is used in the Zentangle Apprentice™ Classroom Pack.

exercise

Get comfortable with your pencil. Hold it upright to make a line (string). Draw lots of swirls and squiggles. Try pressing harder to make darker lines. Next, using the side of your pencil, try pressing as hard as you can to make a black (dark gray) swatch. As you scribble back and forth, lessen the pressure bit by bit. Now you have lighter gray swatches, too. Try to make an even blend that goes from black to very pale gray, rather like a gray rainbow.

Your First Zentangle

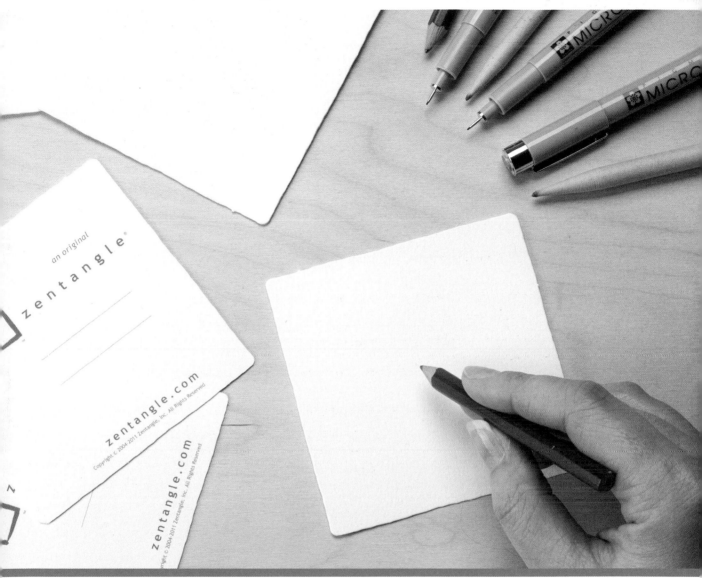

Step 1: Get Focused

A traditional Zentangle is created by following a few simple steps. As you get started, remember that you can't do anything "wrong," and there are no mistakes. Gather all your supplies together, and take a moment to just unwind. Try to clear your mind and breathe. Focus on the tools you have in front of you and the fact that you have this time to relax and achieve a feeling of peace. The blank tile is your space. It can become whatever you want it to be, while you open your mind and achieve a sense of focus and concentration.

 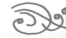

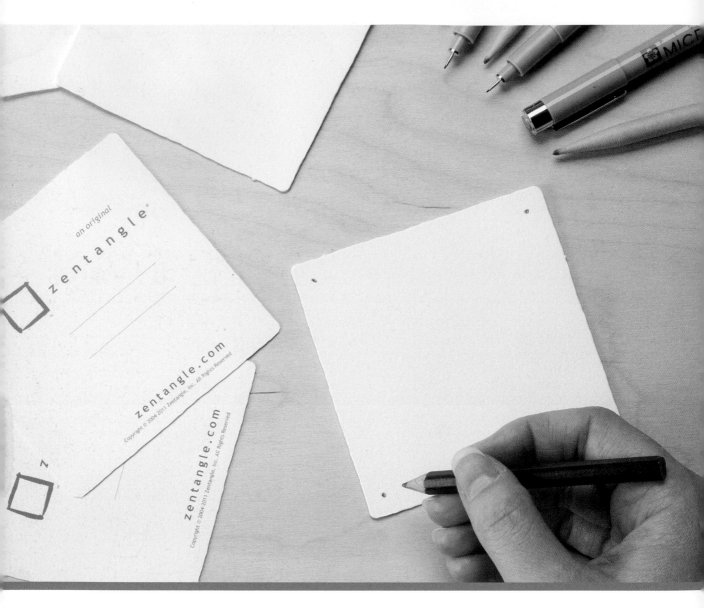

Step 2: Mark the Dots

Make a dot in each corner of your paper tile with a pencil. The dots create points with which to connect your border in the next step. You might also think of them as different aspects of your life, or as a way to balance your tile.

Step 3: Draw the Border

Using your pencil, connect the four dots from the previous step to form your border. You might also think of your border as life's boundaries. Everyone's life needs some boundaries, and the border on a Zentangle tile can represent these boundaries. That being said, everyone's life is different, so the border can be as individual as you are. You can make it with straight lines or curved lines—it's up to you.

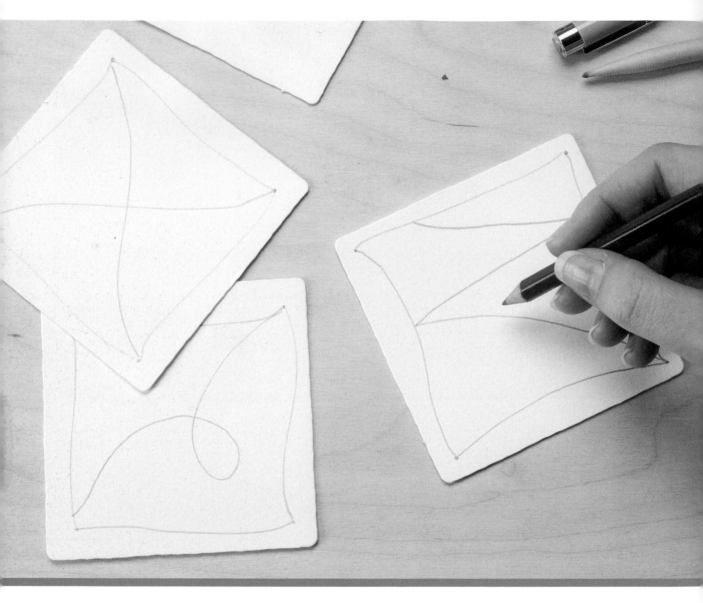

Step 4: Draw the String

Draw a string with your pencil. The string's shape can be a zigzag, swirl, X, circle, or just about anything else that divides the space on your tile into sections. The string does not need to remain within the border you created during the previous step, but can extend off the edges of the tile if you wish—remember, there is no "wrong" in Zentangle. The string represents the golden thread that connects all the patterns and events that run through life. You can also think of each section the string creates as a different area in your life— work, home, school, etc. The string will not be erased, but will disappear as you add your patterns. It can be tempting to think about the shape of the string and how it will look after you have completed this step. Avoid trying to force the sting to have a desired outcome. Instead, let it flow onto your tile.

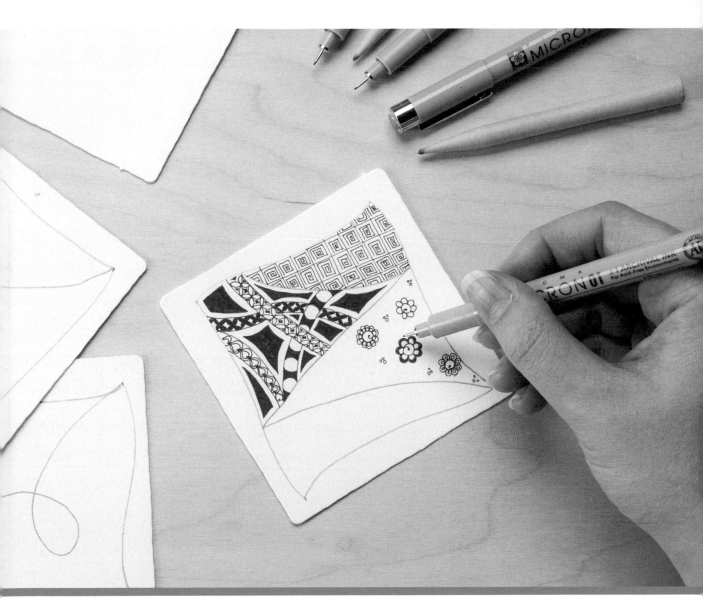

Step 5: Add Tangles and Finish Your Tile

Use a black pen to draw tangles into each section of your tile formed by the string. Rotate the tile as you fill each section with a tangle. When you cross a line, change the tangle. Remember that you cannot erase and must incorporate any perceived "mistakes" in your work into the design. You may leave sections blank if you wish. Once you've filled as many sections of your tile as you desire with tangles, you can use your pencil to add shading and depth (see page 29). Also, make sure you sign your finished piece. You can sign it with your first name, your initials, or a symbol. Because your Zentangle art has no top or bottom, you can sign it anywhere. Then, sign and date the back of the tile and add any comments you wish. Once this is done, take the time to look at your completed Zentangle. Reflect on the peace and relaxation you felt while creating it, and admire your beautiful artwork.

chapter 3

Advanced Zentangle Techniques

A piece of Zentangle art can be as simple as black lines on white paper, or it can be as complex as a fully colored ZIA. When you are first starting out, it's tempting to dive in and apply as many techniques as possible to one tile—after all, Zentangle is exciting! Keep in mind, though, that the Zentangle method is meant to be simple and to free your mind from decision-making. Because of this, keep your first few tiles basic. Use only a pen, pencil, and tile, and concentrate on drawing the lines, dots, and swirls of the patterns you select.

When you have completed a few tiles in this manner and are ready for more, check out this chapter. Here, you will find great advice on adding to your Zentangle designs through shading, changing the shape of your string, or adding borders. There is also great advice about developing your own tangles by drawing inspiration from nature. Use these techniques as much or as little as you want to create your own Zentangle style. For information about adding color to your Zentangle designs, see page 148.

Shading

Shading adds so much to Zentangle art. Compare the two fish ZIAs below. Shading can make objects pop from the page, hide errors (pen slips, smears, etc.), and tone down an overly busy background. You can use shading to add color, contrast, depth, and roundness to a Zentangle or ZIA.

Where to Shade

You can add shading to any number of places on a Zentangle piece, like:

- The sides of spirals
- The backgrounds of Zentangles
- The edges of lines or zigzags
- The edges of sections
- The edges of the Zentangle
- One side of rounded objects
- Anywhere you want!

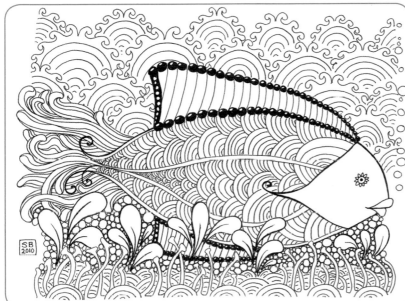

By Sandy Steen Bartholomew, CZT.

Color. The simplest shading just adds a third color to the basic black and white of a Zentangle piece. Try gray in spots where you would normally use solid black or white. It will add interest to dots, checks, stripes, and more.

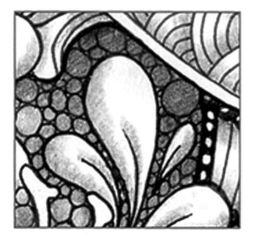

Contrast. A light object against a dark background will be highlighted and pop forward. Dark against light will recede, or look like a hole in the surface. Using gray shading adds a middle ground. In this Zentangle piece, it makes the busy bubbles recede and the plants pop up.

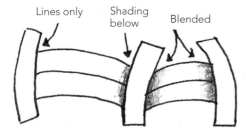

Lines only Shading below Blended

Depth. To make something look like it is going under another object, add a little shadow on either side of the upper object. Notice how the blending gradation actually makes the pattern to the left looked curved.

tip

Use the side of your pencil rather than the tip when shading your tangles.

Flat shading

Here are some tricks for shading flat surfaces.

Layers. Add a bit of shadow under the bottom edges of objects. A crisp shadow makes it look like the objects are close to the surface.

Cutouts. A smudged shadow lifts an object higher off the surface.

Overlap. Add just a little shading on either side of the upper object.

Ground. A smudge of shadow at the base of an object suggests a floor.

Cubed. For cubes, shade one very dark side, one light gray side, and one side stays white.

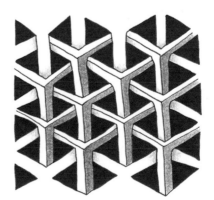

Shine. Shade the tangle so it's light on the "hills" and dark in the "valleys."

exercise

Fill all the sections of a tile with the same tangle. Then, make each one unique by shading it differently than the others.

A black background adds a lot of depth. The contrast makes the lighter objects pop out.

Round shading

Make tangles look "round" with these tricks.

Pearl. Use a "smiley face," or crescent, of shading. Smudge in a circle.

Puffed. Smudge shadow along the bottom edge.

Gradation. Shade the bottom edge, and then blend upward.

Pressed. Shade the top edge; smudge downward.

Really flat and boring.

Roundness created by lines only.

tip

The simplest way to create a new tangle is to work off an old tangle. The next time you draw a tangle, try changing one element to create something new.

Practice Shading

Draw a shape like a circle, and outline it again in pencil. Use your finger or a paper blending stump to smudge the pencil. Blend back and forth and slowly spread the gray away from the circle onto the white paper.

Design Tips

Once you've completed your first Zentangle piece, you'll certainly want to give Zentangle another try using different tangles. And eventually, you'll want to start creating Zentangle-Inspired Art (ZIA). The following are some tips to help you branch out and get creative with your Zentangle designs.

Change the string

Strings are just guidelines, in pencil, put down to create sections within which you can draw tangles. Imagine a piece of thread randomly dropped onto your tile. Random swirlies and loops make great strings. Try using a Z shape, or an X, or other letters. Circles, squares, and triangles are all great. As you progress, your strings will get more complex, like double swirlies, or trees, shells, or fish. Remember, traditional Zentangle art can be viewed from any direction and does not have a top or bottom. Once you give your string a specific shape, like a shell or tree, you are creating Zentangle Inspired Art (ZIA).

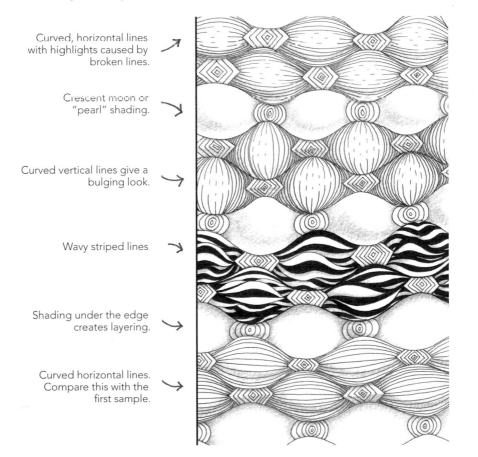

Curved, horizontal lines with highlights caused by broken lines.

Crescent moon or "pearl" shading.

Curved vertical lines give a bulging look.

Wavy striped lines

Shading under the edge creates layering.

Curved horizontal lines. Compare this with the first sample.

Change the shape

A Zendala places a Zentangle piece within the circular shape of a traditional Hindu or Buddhist mandala. Zendalas are a wonderful way to give your favorite tangles a new appearance. Zendalas can be done on square Zentangle tiles, or you can purchase circular Zentangle tiles on which to create your Zendala art.

Frame

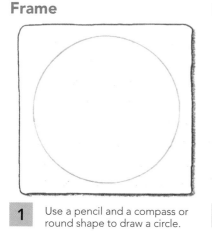

1 Use a pencil and a compass or round shape to draw a circle.

String

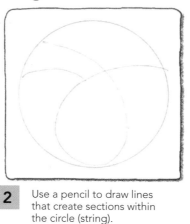

2 Use a pencil to draw lines that create sections within the circle (string).

Tangles

3 Fill a section with a tangle. Fill additional sections with tangles.

Add a border

Tangles can be placed along the edges of your tile to create a border for your completed Zentangle piece. You can also place border tangles between the sections of your tile or fill an entire tile with border tangles. See page 74 for an example of a tangle you can use as a border.

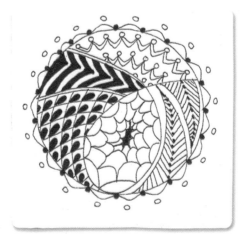

tip Take a series of Zentangle workshops with a Certified Zentangle Teacher. Find one near you at *www.zentangle.com*.

Keeping Tangles

There are hundreds of tangles out there, and you will no doubt come up with a few of your own. Remembering every tangle available to you is pretty much impossible, but there are some great ways to store tangles so you can easily access them when you're ready to start a new Zentangle piece.

These Zentangle trading cards will fit in plastic baseball card collector pages.

Artist trading cards. Make yourself a Zentangle artist trading card (ATC) like the one shown out of an index card or cardstock. You can keep the cards in a binder in the plastic sheets used to hold photos or baseball cards. That way, you can see all your tangles at a glance, as well as the steps used to create each one.

Use a metal ring, or a paper clip, to hold a whole bunch of tags together.

Tags and rings. Draw your tangles on tags that have a hole punched in the top (or create the hole yourself). The tags can then be stored on a metal ring so you can flip through them whenever you need inspiration.

Draw from Real Life

The photos on these two pages were all taken at Old Sturbridge Village in Massachusetts. You never know where you will see wonderful patterns! Photos and tangles by Sandy Steen Bartholomew, CZT.

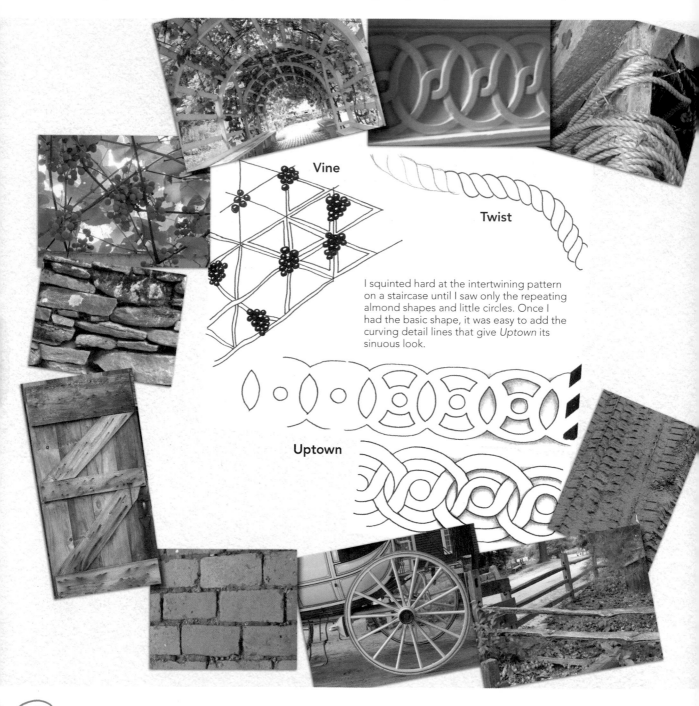

Vine

Twist

I squinted hard at the intertwining pattern on a staircase until I saw only the repeating almond shapes and little circles. Once I had the basic shape, it was easy to add the curving detail lines that give *Uptown* its sinuous look.

Uptown

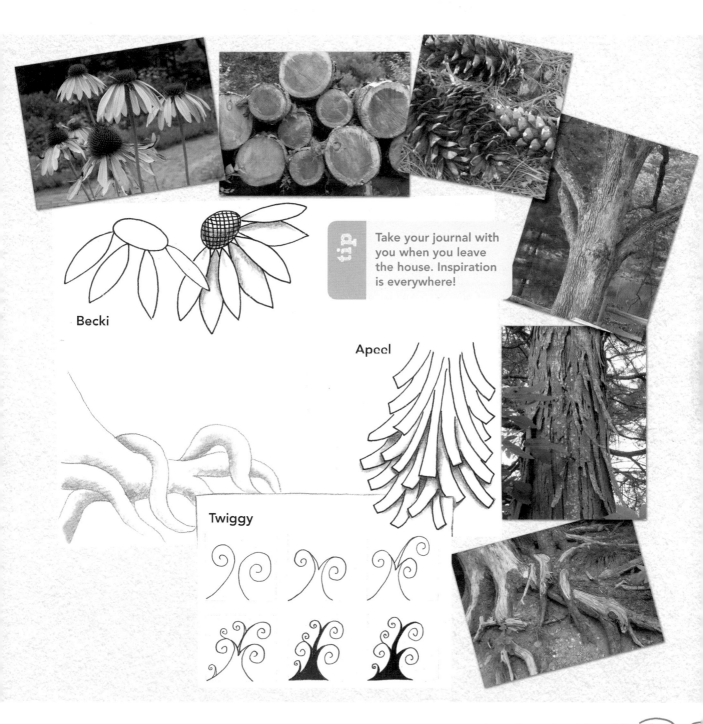

Becki

tip

Take your journal with you when you leave the house. Inspiration is everywhere!

Apeel

Twiggy

Tangle Directory

The Zentangle method allows for endless possibilities, so there are hundreds of tangles available for you to use. Sometimes the most difficult thing about creating Zentangle art is finding the right tangles. The following is a directory of the 101 tangles found in Chapter 5. Use this as a quick reference guide to see the variety of options available to you before you start a Zentangle piece. Browse these pages to find tangles that catch your eye. Then, turn to the appropriate pages in Chapter 5 and follow the step-by-step guides to draw those particular tangles. The tangles are listed alphabetically, so you can easily find your favorites later. Select a few now and start tangling!

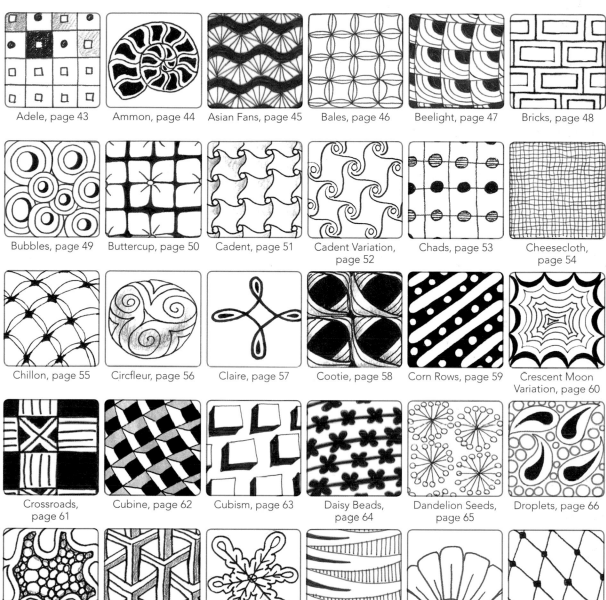

Adele, page 43

Ammon, page 44

Asian Fans, page 45

Bales, page 46

Beelight, page 47

Bricks, page 48

Bubbles, page 49

Buttercup, page 50

Cadent, page 51

Cadent Variation, page 52

Chads, page 53

Cheesecloth, page 54

Chillon, page 55

Circfleur, page 56

Claire, page 57

Cootie, page 58

Corn Rows, page 59

Crescent Moon Variation, page 60

Crossroads, page 61

Cubine, page 62

Cubism, page 63

Daisy Beads, page 64

Dandelion Seeds, page 65

Droplets, page 66

Ennies, page 67

Etcher, page 68

Flake, page 69

Floating Disks, page 70

Flora, page 71

Florz Variation, page 72

Flukes, page 73

Flutter, page 74

Flutter Tile, page 75

FlutterBi, page 76

Flying Geese, page 77

Footprints, page 78

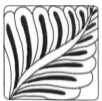
Frond, page 79

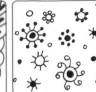
Germie, page 80

Gewgle, page 81

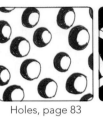
Growth, page 82

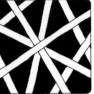
Holes, page 83

Hollibaugh,
page 84

Intersection,
page 85

Itsy Bitsy, page 86

Jonqal Variation,
page 87

Jute, page 88

Kathy's Dilemma,
page 89

Keeko, page 90

King's Crown,
page 91

Knight's Cross,
page 92

Knightsbridge,
page 93

Krust, page 94

Kuginuki, page 95

Lacy, page 96

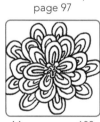
Lettuce Farm,
page 97

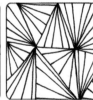
Lollipops, page 98

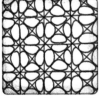
Marbles, page 99

Matt, page 100

Melody, page 101

Mixed Signals,
page 102

Mumsy, page 103

Munchin, page 104

Nipa, page 105

'Nzeppel, page 106

Orange Peel,
page 107

Papyrus, page 108

Pinwheels,
page 109

Popova, page 110

Printemps,
page 111

Printemps Variation,
page 112

Puff-O, page 113

Purlbox, page 114

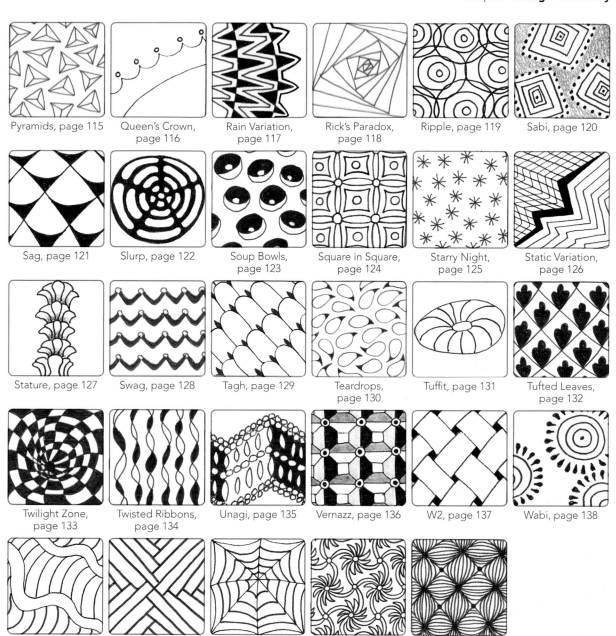

Pyramids, page 115

Queen's Crown, page 116

Rain Variation, page 117

Rick's Paradox, page 118

Ripple, page 119

Sabi, page 120

Sag, page 121

Slurp, page 122

Soup Bowls, page 123

Square in Square, page 124

Starry Night, page 125

Static Variation, page 126

Stature, page 127

Swag, page 128

Tagh, page 129

Teardrops, page 130

Tuffit, page 131

Tufted Leaves, page 132

Twilight Zone, page 133

Twisted Ribbons, page 134

Unagi, page 135

Vernazz, page 136

W2, page 137

Wabi, page 138

Waves, page 139

Weave, page 140

Web, page 141

Whirls, page 142

Yincut, page 143

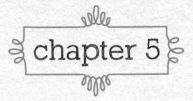

chapter 5

Learn to Draw 101 Tangles

No matter how complicated the finished product might appear, every single tangle can be broken down into a series of repetitive markings. This chapter will take you through the steps to create 101 tangles. Along the way, you'll find some stunning art, and stories from CZTs and other individuals who have felt the impact of the Zentangle method in their lives.

The tangles you draw do not have to look identical to the ones printed here. On the contrary, each tangle should reflect you through its lines, shading, etc. Also remember that there are no mistakes. If you add an extra line, dot, or swirl to one of these tangles, use your creativity to make it part of the design. And finally, feel free to create variations of these tangles. Change straight lines to curves, or fill in a different section than the one indicated—there are limitless possibilities!

Adele

Tangle by Sandy Steen Bartholomew, CZT.

Zentangle Round Robbins

Host a Zentangle exchange where each person provides scrapbook pages, photos, or journals, and have each member add something like a border, title, embellishment, or journaling box. Because Zentangle art is done in steps, it can be finished at a party or social hour. It's really fun to start, and then pass the designs around, with everyone completing a step. When the project gets back to its originator, each person has a wonderful collage created by her friends.

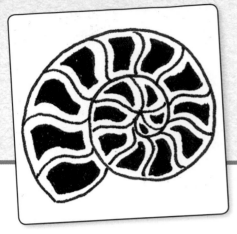

Ammon

Tangle by Sandy Steen Bartholomew, CZT.

Asian Fans

Tangle by Suzanne McNeill, CZT.

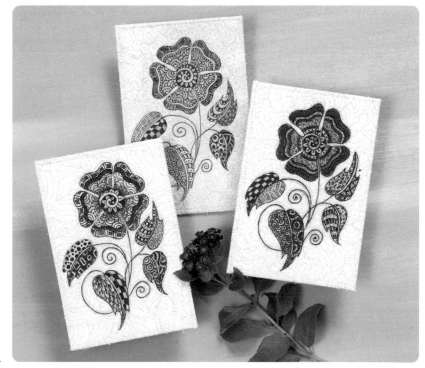

Fabric postcards by Jill Buckley.

Bales

Tangle by Rick Roberts and Maria Thomas.

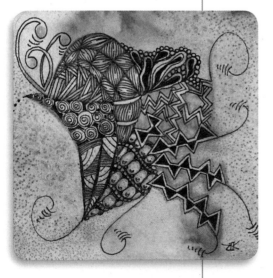

Zentangle Inspiration

Tranquility. The *World English Dictionary* defines it as "a state of calm or quietude." Most of us search for those islands of tranquility in our busy lives. For some, it is achieved through meditation, music, physical activity, journaling, or hobbies. I was always a bit envious of those people. My mind never stops, so meditation and music don't do it for me. My perfectionism and tendency toward boredom once I master something ruled out most of the other options. At the ripe old age of 49, I figured this just wasn't in the cards for me.

In September, on a perfectly ordinary Monday afternoon, my family was turned upside down. We came within a whisper of losing our oldest daughter and her two children in an auto accident. I was the one who kept it all together. It is who I am—the one my family can always count on. All three of them recovered; however, our family was forever changed by the experience—mostly for the better.

So how does this relate to my quest for tranquility? About two months after the accident, the emotions I had switched off to deal with the crisis decided it was time to make an appearance—all at once. I struggled to find a way to deal with the maelstrom roiling in my brain. Then, a friend posted a link on Facebook. It was a video demonstrating the Zentangle method. There was an effortless magic to the drawing. I had to try it—something about it called to my soul. As I explored the world of Zentangle and began to actively create my own works of art, I discovered something amazing. When I was tangling, my mind would quiet and begin to calm. Blessed Tranquility.

And so I begin…sharing my Tangled Tranquility with others and trying to pay it forward in my corner of the world. Thank you for joining me.

—Kathy S. Redmond, CZT

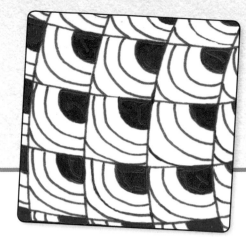

Beelight

Tangle by Rick Roberts and Maria Thomas.

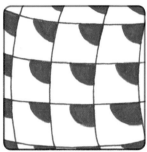

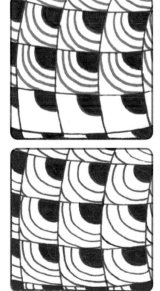

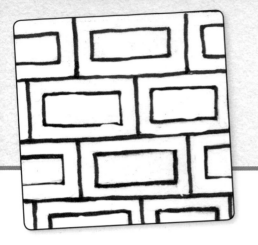

Bricks

Tangle by Suzanne McNeill, CZT.

VARIATION 1 VARIATION 2

Bubbles

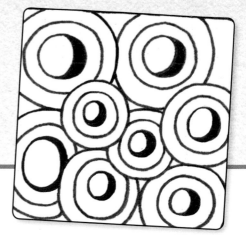

Tangle by Suzanne McNeill, CZT.

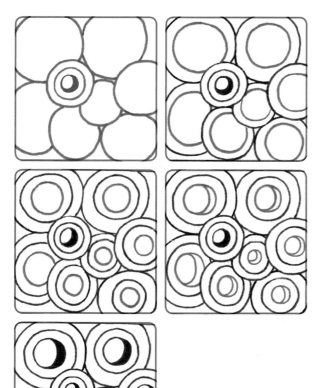

Zentangle Inspiration

Zentangle is my therapy. When I'm doing a tangle, I lose total track of time and what is happening around me. The first time I saw the Zentangle method online, I fell in love with the intricate patterns. My thought was how great this would look on fabric. I'm a quilter—I have been hooked on fabric for years, and now I'm hooked on Zentangle.

When I said Zentangle is my therapy, I really wasn't being dramatic. I have multiple sclerosis (MS). When I do tangles, I am totally absorbed. I don't notice the pain and fatigue I have with the disease. Nobody who sees my Zentangle art will think somebody who isn't normal and healthy did it. I don't feel disabled when I tangle. I love that feature of Zentangle.

—Lynda Leeper

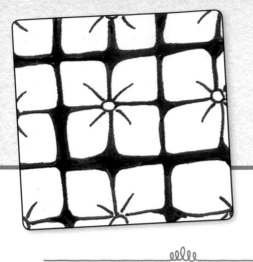

Buttercup

Tangle by Sandy Steen Bartholomew, CZT.

Club Tangles

Enthusiastic "Tanglers" who have taken an introductory Zentangle class often meet regularly to share Zentangle creations and learn about new patterns. Clubs form a camaraderie, and members show how to create Zentangle art on pages and cards. This infectious excitement often spills over into other areas of friendship.

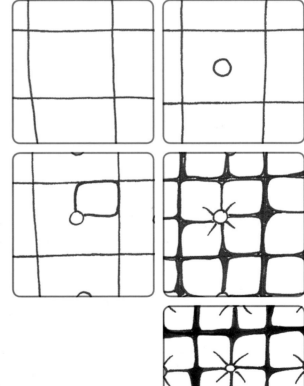

By Sandy Steen Bartholomew, CZT.

Cadent

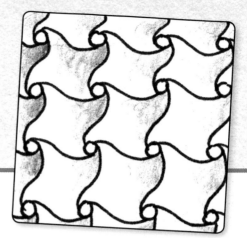

Tangle by Rick Roberts and Maria Thomas.

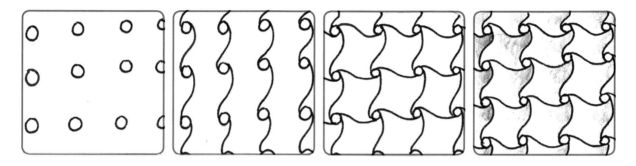

Zentangle Inspiration

I was introduced to the Zentangle method through my local scrapbooking store. I took the class on a whim one Friday, and on the following Monday, I was sidelined with a long-term illness that kept me off my feet for months. I am not a sickly person, so I was struggling to cope with my condition. When I took the Zentangle class, I had wondered how I would find time to practice what I had learned, and suddenly, it was just about all I could do. So I practiced tangling all day long, every day for several months.

The doctors and personal friends were amazed at my positive attitude, which I attributed to Zentangle. Eventually, with encouragement from Rick and Maria, I became a CZT. I now understand Zentangle and how it helps people, especially if they are sick or in pain. I have taught many people how to tangle, from age four all the way up to eighty-six. I do tiles in restaurants, and inevitably someone will ask what I'm doing. I love sharing my work with others—I've even had some pieces featured in magazines like *The Stampers' Sampler*. You can also see some of my ZIA pieces on my blog: *www.renee-boltonhouse.blogspot.com*.

—Renee Zarate, CZT

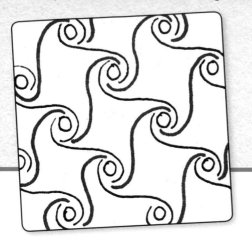

Cadent Variation

A variation on a tangle by Rick Roberts and Maria Thomas.
Tangle by Suzanne McNeill, CZT.

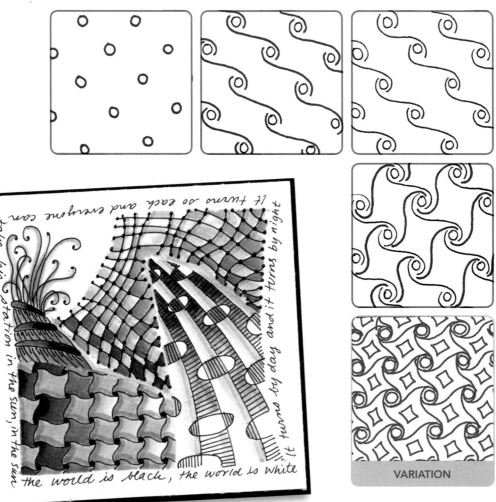

VARIATION

By Marie Browning, CZT.

Chads

Tangle by Sandy Steen Bartholomew, CZT.

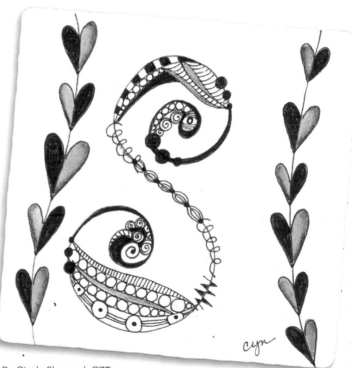

By Cindy Shepard, CZT.

Cheesecloth

Tangle by Suzanne McNeill, CZT.

Zentangle Inspiration

I found Sandy Steen Bartholomew's book *Totally Tangled* at my library and started tangling right away. This was also the same month I discovered National Novel Writing Month and decided to write my first novel! I am convinced that Zentangle is what enabled me to meet my writing goal of 50,000 words.

Two months later, I became a CZT. Since then, I have discovered that I have a passion for sharing this blessing with others. Seeing students' faces light up at the end of class is priceless. I had one customer tell me, "I didn't know I was an artist until I came to this class." What could be a better gift?

On a personal note, Zentangle has given me the confidence to begin making art. When I was a child, I wanted to be an artist, but never had the courage to pursue that dream. In the last year and a half, I have started taking art lessons and begun painting again. I know I would never have done this without Zentangle.

—Cris Letourneau, CZT

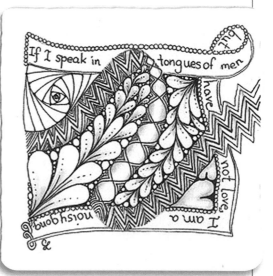

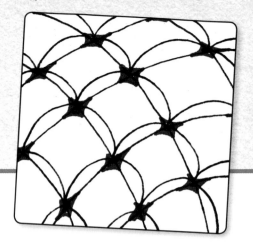

Chillon

Tangle by Rick Roberts and Maria Thomas.

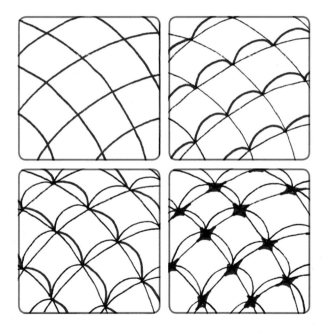

Circfleur

Tangle by Sandy Steen Bartholomew, CZT.

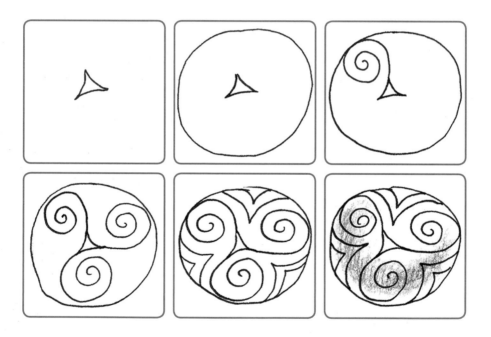

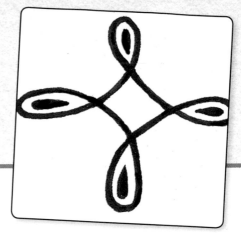

Claire

Tangle by Sandy Steen Bartholomew, CZT.

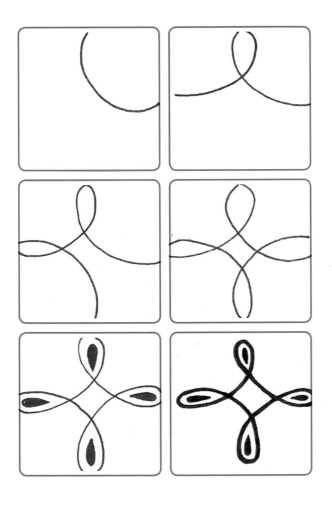

Zentangle Inspiration

Patterns are everywhere, and now I have an almost endless supply of projects for them. As a retailer of cutout shapes for another craft (iris folding), I was getting a little burned out. When I discovered Zentangle at a craft trade show, I had a profound epiphany—I could use my cutouts as stencils and fill the space with tangles. This was a whole new direction and use for my cutouts. I wanted to become a CZT to further explore this amazing process, and I wasn't disappointed. Zentangle creators (Rick and Maria), their method, and the Zentangle community couldn't be more nurturing and stimulating.

—Dedra True-Scheib, CZT

Cootie

Tangle by Sandy Steen Bartholomew, CZT.

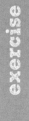

Draw your favorite tangle… BIG! The more complex the pattern, the more fun it is to fill it with other tangles.

Corn Rows

Tangle by Suzanne McNeill, CZT.

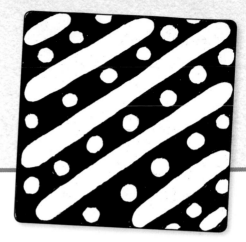

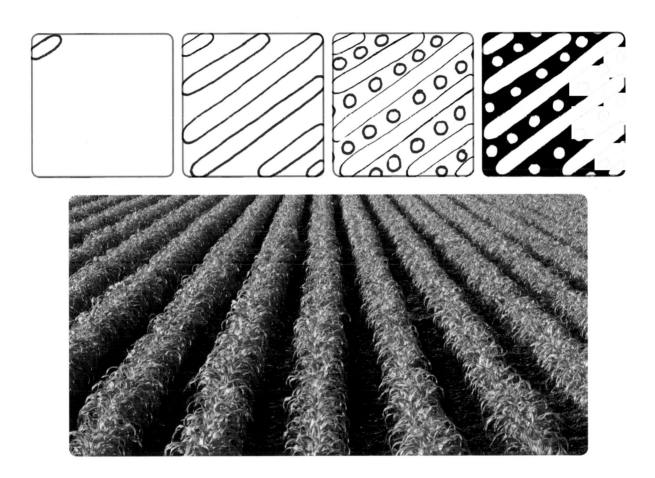

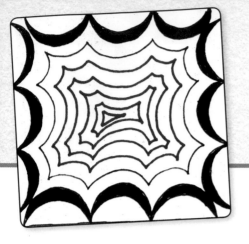

Crescent Moon Variation

Tangle by Suzanne McNeill, CZT.

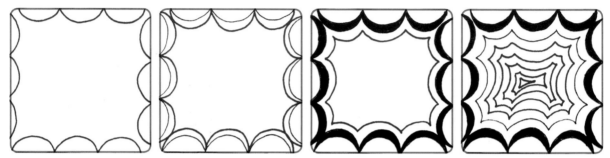

Zentangle Inspiration

Every summer, I try to learn something new. One summer, I wanted to learn how to make floorcloths and found a class at a local art school. I then found myself torn, because there was another intriguing class, given at the exact same time, called Zentangle. I looked it up online and decided that a) I loved the art, and b) I could teach myself, and so I took the floorcloth class.

Leaving out the details, I wish I had foregone the floorcloth class and taken the Zentangle class! I do make floorcloths, and I did take a Zentangle class a year later. It made a world of difference from learning on my own. It opened me up to being an artist. I have used Zentangle traditionally and non-traditionally, and became, at long last and with a thousand thanks to Rick and Maria, a CZT. Now I tangle, draw, paint, and live life more fully. I am lucky to be able to incorporate Zentangle into my day job and share it with so many people.

—Maya Bhatt-Hardcastle, CZT

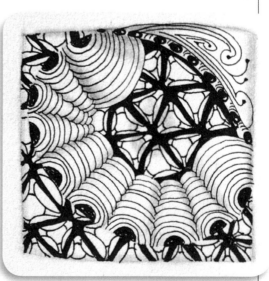

Crossroads

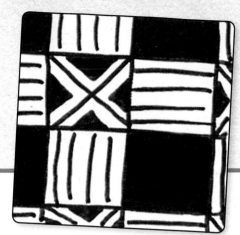

Tangle by Sandra Strait.

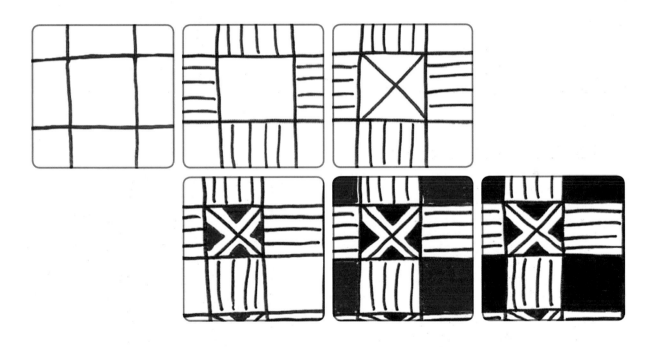

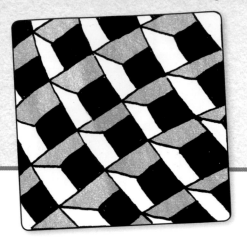

Cubine

Tangle by Rick Roberts and Maria Thomas.

Cubism

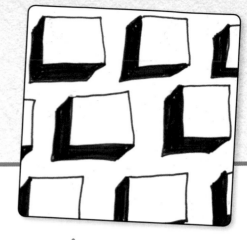

Tangle by Suzanne McNeill, CZT.

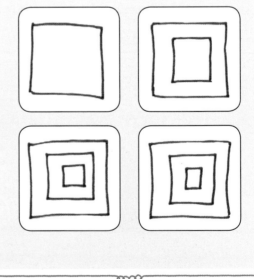

Symbolism: Squares

The symbol of rational thought, this shape with equal sides and equal angles represents stability and can be considered the cornerstone of achievement.

Daisy Beads

Tangle by Suzanne McNeill, CZT.

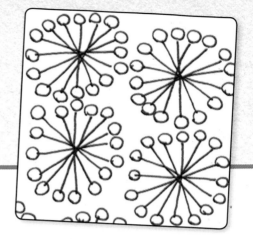

Dandelion Seeds

Tangle by Suzanne McNeill, CZT.

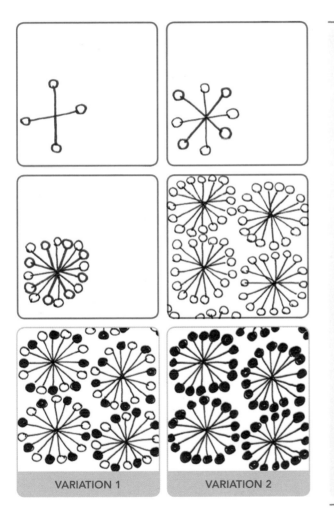

VARIATION 1 VARIATION 2

Learning with Zentangle

The Zentangle method can help kids master spelling, math, and geometry. Kids can draw block letters on a paper tile and tangle in or around them to help remember the shape of each letter. Create flashcards that contain a simple math equation with a Zentangle background to connect the equation with an image. Finally, use Zentangle pieces with squares, circles, and triangles for a basic geometry lesson.

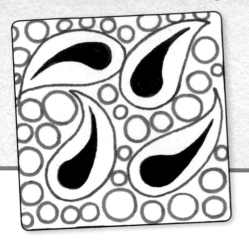

Droplets

Tangle by Suzanne McNeill, CZT.

 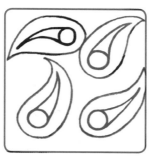 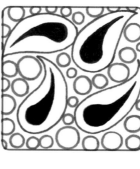

VARIATION

Zentangle Inspiration

Life is full of surprises, and I believe that the right things happen at the right time of our lives and dreams do come true. Ever since I learned to crochet at age fourteen, my hands have been busy with many styles of craft and creating. Sharing my handmade bits and pieces has been an enjoyable part of my life, but I have never had such an addictive, creative passion until Zentangle.

We were on holiday, and destiny played its part when Zentangle jumped off a magazine page at me. In that moment, I had a strange feeling that this was something I had to do. My days since have been filled with much more artistic creativity than I could have imagined.

I went on to complete my first Zentangle dream—to tangle every day for one year and post on my blog. My next dream came true when I traveled (with my husband) from Tasmania, Australia, to Providence, Rhode Island, to become a CZT.

I feel that drawing in the Zentangle style has helped me be more calm, patient, flexible, appreciative, and has helped me realize everything will turn out right in the end and "anything is possible, one stroke at a time."

—Michele Beauchamp, CZT

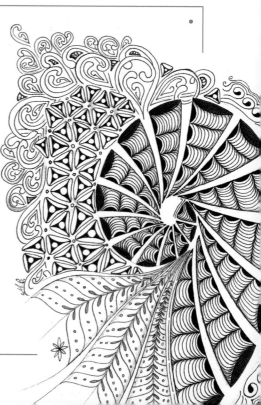

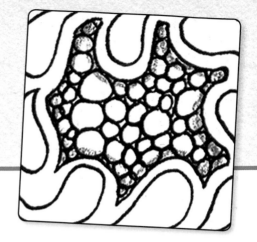

Ennies

Tangle by Rick Roberts and Maria Thomas.

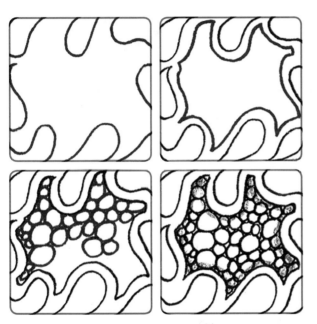

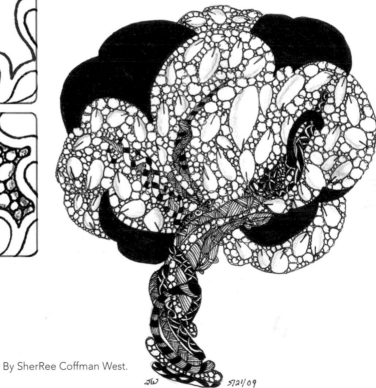

By SherRee Coffman West.

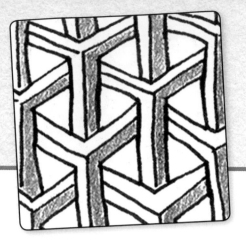

Etcher

Tangle by Sandy Steen Bartholomew, CZT.

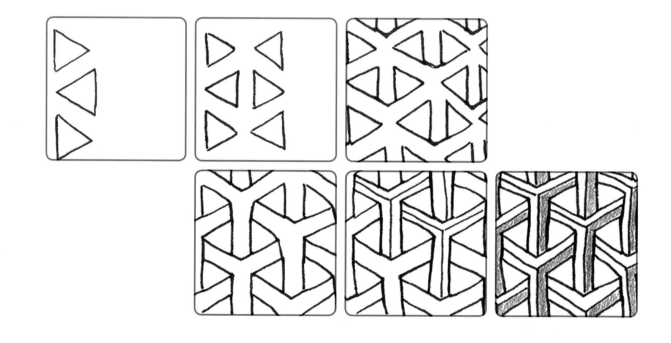

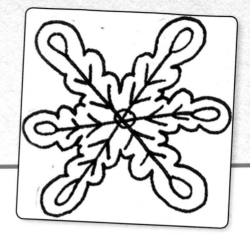

Flake

Tangle by Sandy Steen Bartholomew, CZT.

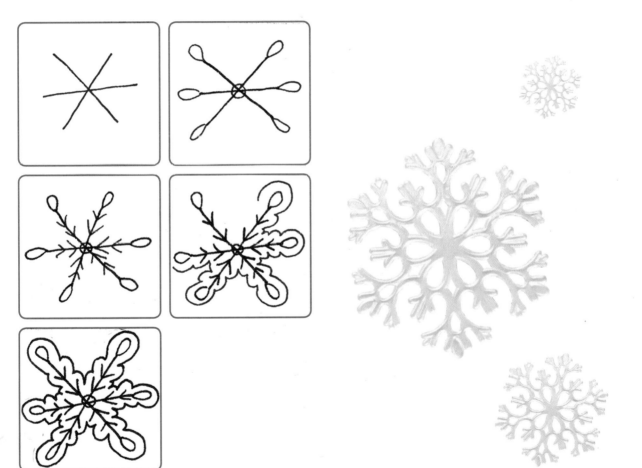

Floating Disks

Tangle by Suzanne McNeill, CZT.

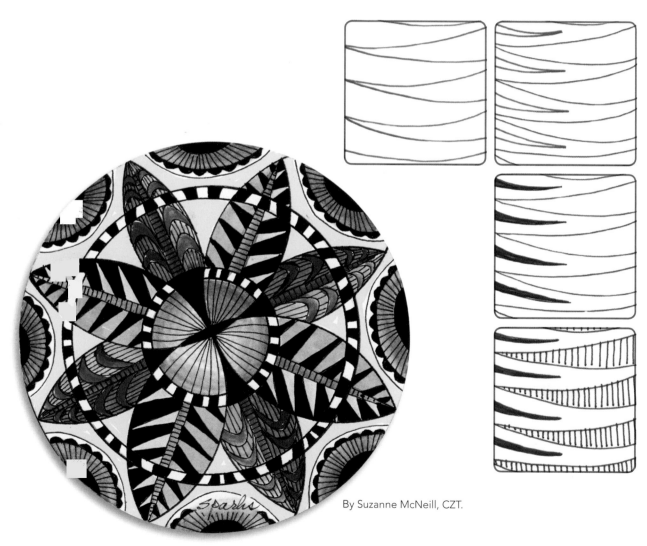

By Suzanne McNeill, CZT.

Flora

Tangle by Sandy Steen Bartholomew, CZT.

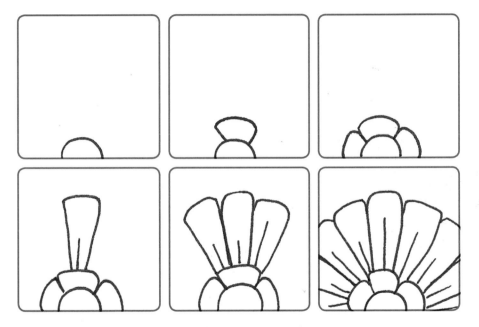

exercise

Take a walk around outside your house, apartment, hut, or igloo.
Examine the ground, the plants, even the sky!

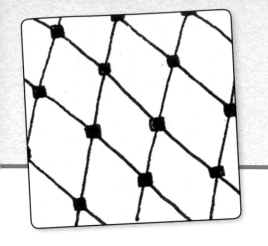

Florz Variation

Tangle by Sandy Steen Bartholomew, CZT.

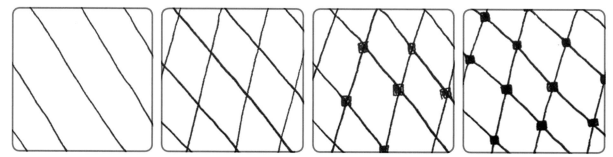

Zentangle Inspiration

At the urging of a friend, I took an introductory Zentangle class at the beginning of my weeklong spring break from school. I am a school nurse at a middle school and was quite ready for a break! My friend was the one mainly interested in learning the technique, and I was going along for the opportunity to do something with her, because we don't see each other very often. As things worked out, my friend enjoyed the workshop, but I fell in love with Zentangle! Each day throughout that spring break, I spent a couple of hours making Zentangle art. I find the process of tangling to be relaxing, and it helps me think through problems or issues in my life. Somehow, when I have part of my brain focused on making each line, another part of my brain is freed up to sort things out.

I have shared my enthusiasm with friends in several settings. My church had a statewide retreat where I showed people who were interested what I was doing. One nine-year-old boy who has struggled with learning to read tried Zentangle and was heard to say, "I am *so* going to do this!" He felt successful at something! I also shared it with my family at a reunion, where I was thrilled to see my brother and his wife enjoy it together!

—Lois Henderson

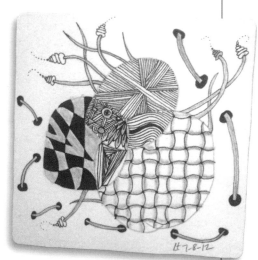

Flukes

Tangle by Rick Roberts and Maria Thomas.

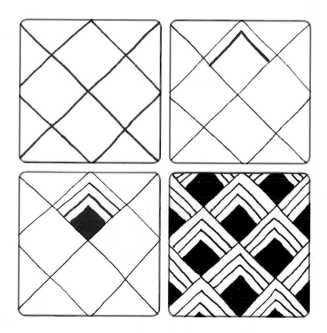

Flutter

Tangle by Sandy Steen Bartholomew, CZT.

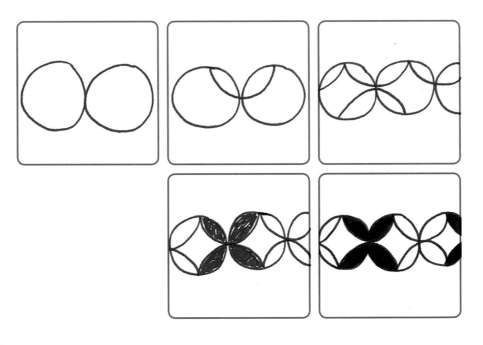

tip Buy a blank journal with quality paper you can fill with your thoughts and your Zentangle art. It's portable, so you can take it with you wherever you go.

Flutter Tile

Tangle by Sandy Steen Bartholomew, CZT.

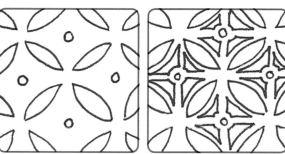

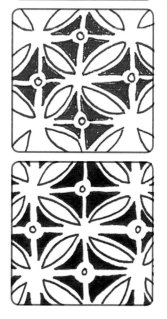

Zentangle Inspiration

I have loved art my whole life, but never felt my drawing was good enough. I was browsing the Internet more than a year ago looking for how-to books to improve my drawing. There were several Zentangle books that caught my attention, and I ordered them without even knowing what they were about. I now have every Zentangle book that is out there—I'm totally addicted. I have found that I can draw and my drawings are pretty darn good. Zentangle has given me confidence, self-esteem, and the freedom to explore my drawing. Since creating my first Zentangle, I have opened an Etsy store and become a Certified Zentangle Teacher. Through this method, I found I can look at drawings in a different way. As Rick Roberts and Maria Thomas say "Anything is possible one stroke at a time!". It is very true.

—Marta Drennon, CZT

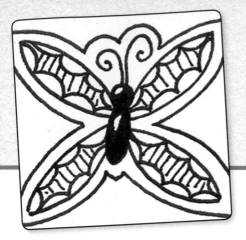

FlutterBi

Tangle by Sandy Steen Bartholomew, CZT.

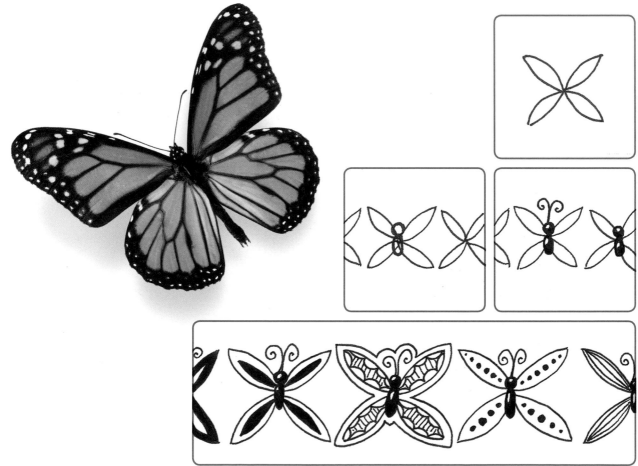

Flying Geese

Tangle by Suzanne McNeill, CZT.

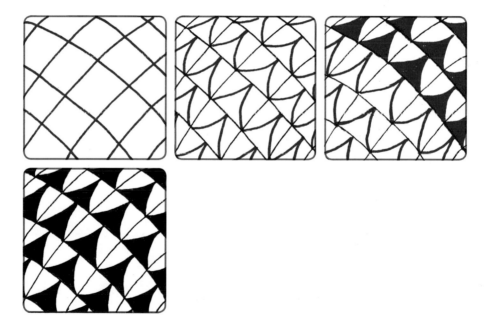

Footprints

Tangle by Suzanne McNeill, CZT.

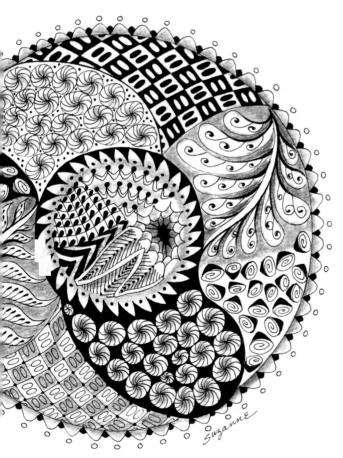

By Suzanne McNeill, CZT.

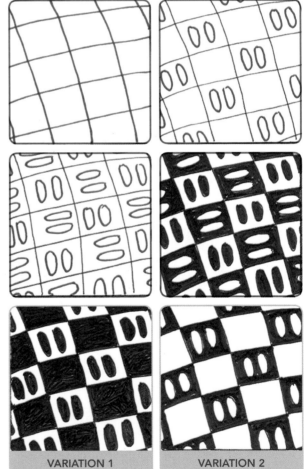

VARIATION 1

VARIATION 2

Frond

Tangle by Suzanne McNeill, CZT.

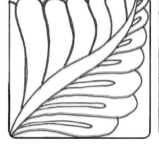
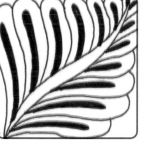

Symbolism: Flowers and Leaves

Representing eternal rebirth, flowers form naturally in the shape of mandalas. Use them to signify personal growth and life energy.

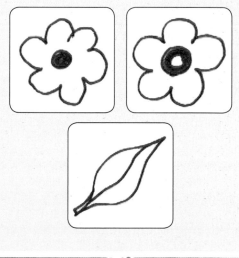

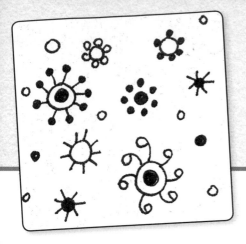

Germie

Tangle by Marie Browning, CZT.

Zentangle Inspiration

Lying on the floor during a meditation class, my heart started racing. I couldn't breathe. Instead of relaxing, I went into a full-blown attack. Not my thing. Instead, I learned to fidget and twirl my hair—not particularly attractive habits. Then, a friend showed me Zentangle. She claimed that it was a sort of meditation on paper. I admit I was skeptical, but I have found Zentangle to be soothing—and exhilarating. It calms me, helps me focus my energy, and leaves me feeling refreshed. In fact, tangling is so useful to me as an author that I've volunteered to teach it to other writers at an upcoming conference. I tangle before I get down to my writing each day. The time I spend tangling allows me to be much more productive. This works so well that I will have completed three books in nine months. No doubt about it: Zentangle fills the empty spaces in my creative life, and, curiously, it also enlarges my world.

—Joanna Campbell Slan

Tangling helps author Joanna Campbell Slan become focused and energized, allowing her to write books like this one.

Gewgle

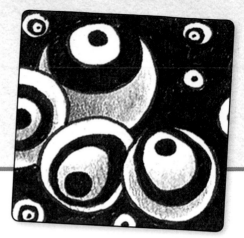

Tangle by Sandy Steen Bartholomew, CZT.

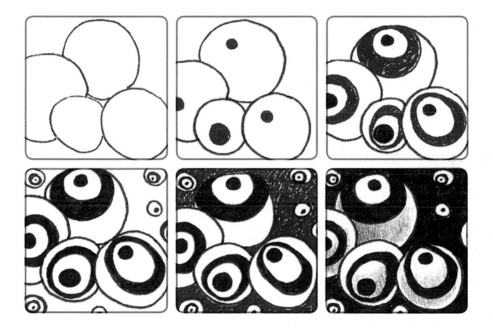

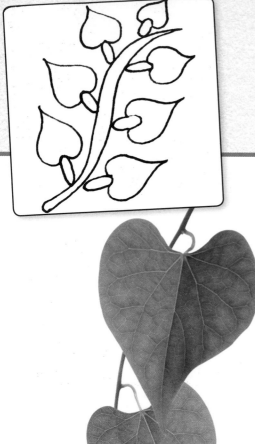

Growth

Tangle by Suzanne McNeill, CZT.

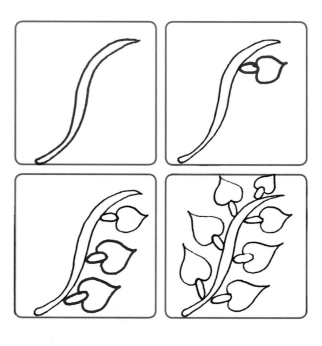

Holes

Tangle by Suzanne McNeill, CZT.

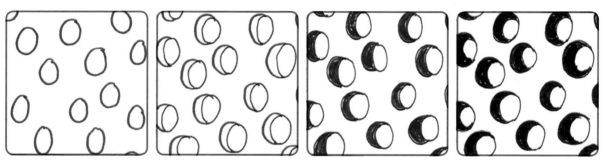

Zentangle Inspiration

I first encountered the Zentangle method through my work at Fox Chapel Publishing. We have several books on the subject, and when I saw our customers' interest in it, I decided to look into Zentangle myself. I quickly fell in love with it.

Zentangle is a perfect way for me to quiet my mind and relieve stress. I use it in church as a way to concentrate on the service. I also use it when I pray, creating tangles with a specific individual in mind. I name each prayer tangle, and will sometimes give the drawings to the individuals. It's nice because it's something tangible.

I don't claim to have any artistic ability (besides knitting), but Zentangle allows me to produce beautiful works of art that are meaningful and empowering. I make sure I set aside about an hour each evening to tangle. Zentangle has also given me a way to pray for my husband, who struggles with a rare blood disorder and heart problems. Zentangle is what I rely on to quiet my mind and pray.

—Cindy Fahs, CZT

Hollibaugh

Tangle by Rick Roberts and Maria Thomas.

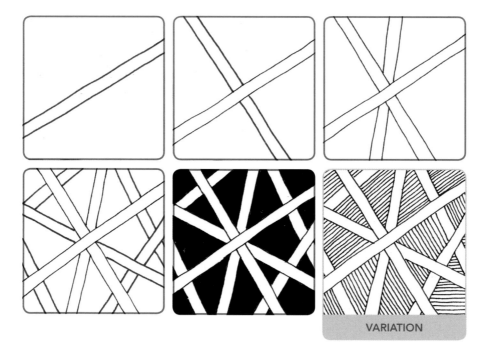

VARIATION

Intersection

Tangle by Suzanne McNeill, CZT.

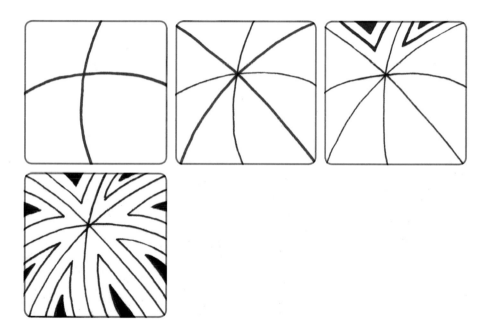

Itsy Bitsy

Tangle by Suzanne McNeill, CZT.

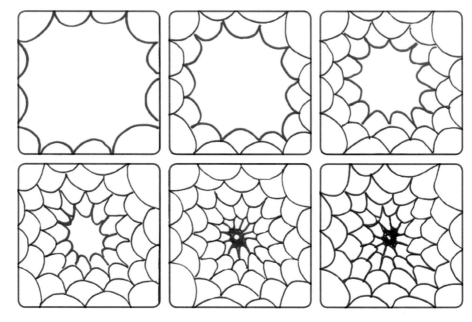

exercise

Try combining four similar tangles, or four of your favorite tangles to make a completely new one.

Jonqal Variation

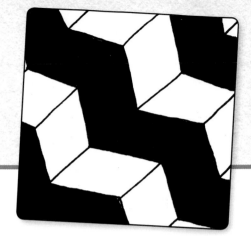

A variation on a tangle by Rick Roberts and Maria Thomas.
Tangle by Suzanne McNeill, CZT.

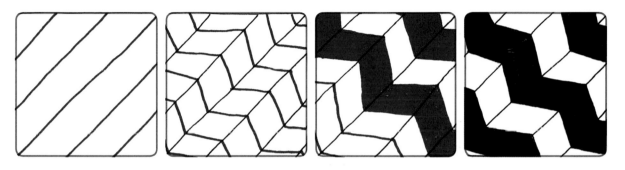

Zentangle Inspiration

Within ten minutes of my first Zentangle piece, I was completely enchanted! I became a Certified Zentangle Teacher (CZT) the next year, and also started the Zentangle Club of N.E. Ohio. We have had three Zentangle art shows, two Zentangle-O-Ramas, one Zentangle Extravaganza, and extra workshops outside of meetings. We are proud to have five CZTs who are active in our club.

I teach the Zentangle method to boys and girls at local crisis centers for teens. One young man really got into the Zentangle process, and was talking enthusiastically during class. I found out that he had been there three times and had hardly said a word to anyone until then! Teens really love Zentangle because it gives them peace and calm on their own terms.

When I taught a kindergarten class, I had to drop half of my lesson plan because the students were so open and creative. Our local art museum had an Escher exhibit, and I got the chance to teach their teen council, and then all of us got inspired by Escher, with tangible Zentangle results.

Zentangle art is an extraordinary blessing to me, and a gift I love to give to people of all ages!

—Carol Bailey Floyd, CZT

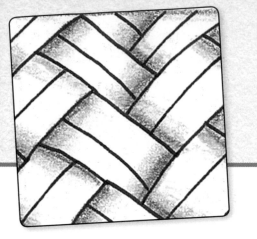

Jute

Tangle by Sandy Steen Bartholomew, CZT.

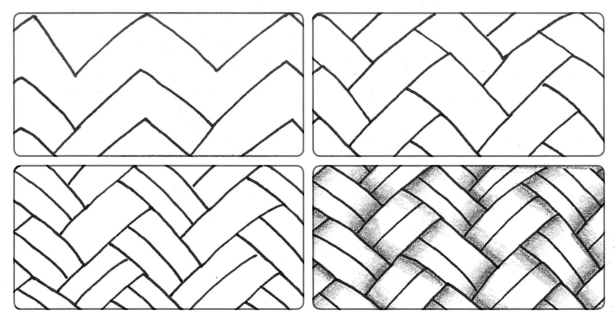

Kathy's Dilemma

Tangle by Kathy in Atlanta.

| VARIATION 1 | VARIATION 2 | VARIATION 3 |

Symbolism: Triangles

The double triangle, forming a six-pointed star, represents fulfillment and harmony. The upward triangle represents the fire of creative life force, while the downward triangle symbolizes water and potential. Because triangles rotate on a center point, they also indicate change.

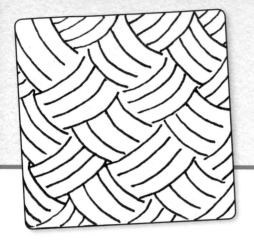

Keeko

Tangle by Rick Roberts and Maria Thomas.

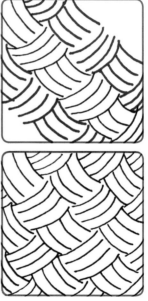

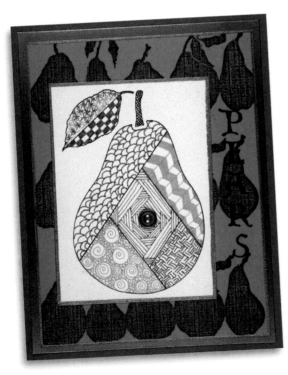

Pear card by Kristi Parker Van Doren.

King's Crown

Tangle by Suzanne McNeill, CZT.

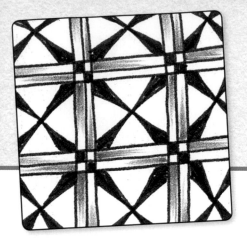

Knight's Cross

A variation on *Knightsbridge*, a tangle by Rick Roberts and Maria Thomas. Tangle by Marie Browning, CZT.

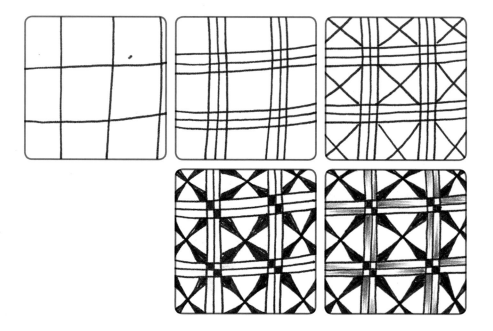

Knightsbridge

Tangle by Rick Roberts and Maria Thomas.

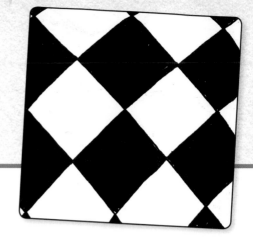

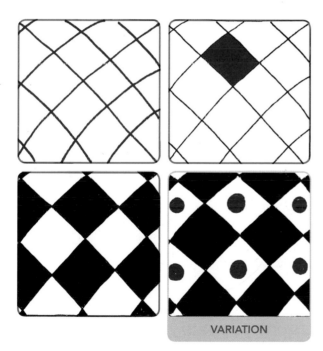

VARIATION

Krust

Tangle by Sandy Steen Bartholomew, CZT.

Zentangle Inspiration

I was introduced to the Zentangle method not very long ago, yet it feels like I have been doing it forever. A crafty person by nature, I have tried my hand at drawing and painting on many occasions, but always found the end result less than acceptable. Consequently, the time invested seemed a waste. I was always left feeling frustrated both artistically and spiritually.

Zentangle changed all that! Much like a form of meditation, or the constant motion of knitting needles (neither of which I have the patience for), creating a Zentangle piece takes me to a place of focus and calm, where I can tune the whole world out and revel in the amazing gift of creating and the absolute joy it brings me as the perfect artistic outlet. Each Zentangle creation is more beautiful than the last, and no artistic capability is necessary. You can't mess up! Now, I create at least one Zentangle piece a day. It is the gift I give myself, because it takes me to a place of peace and honors my need and desire to create beautiful works of art without the frustration and disappointment of not being good enough.

—Lisa Stearns

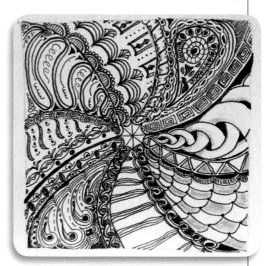

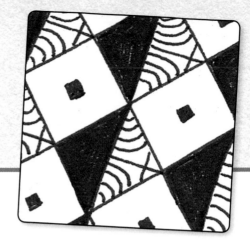

Kuginuki

Tangle by Sandy Steen Bartholomew, CZT.

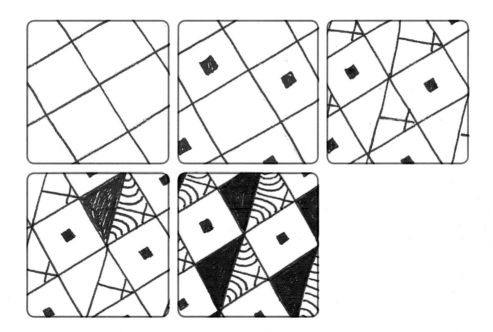

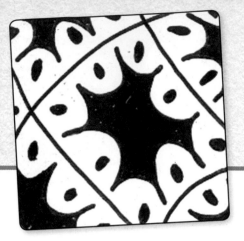

Lacy

Tangle by Sandra Strait.

Friendship Tangles

Draw on a large piece of cardstock. Add the string and make many sections (at least one for each friend). Ask each person to draw a tangle in a section. At the end, you'll have a wonderful piece of art created by many hands and talents.

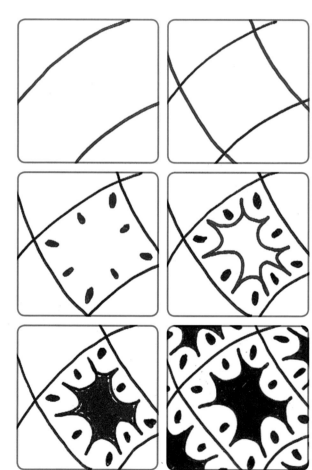

Lettuce Farm

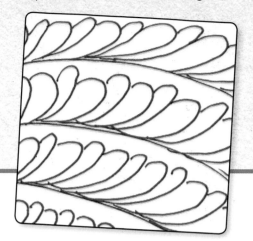

Tangle by Suzanne McNeill, CZT.

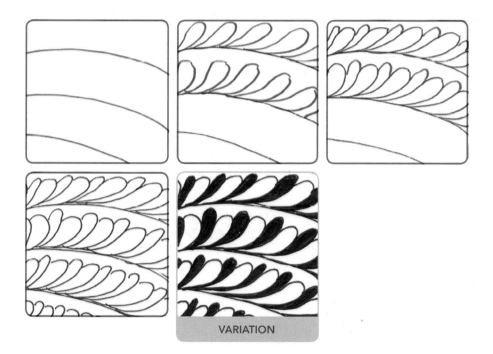

VARIATION

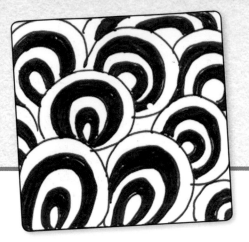

Lollipops

Tangle by Suzanne McNeill, CZT.

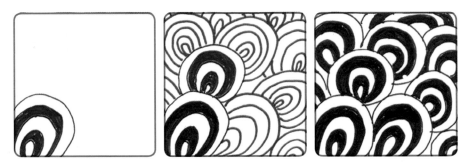

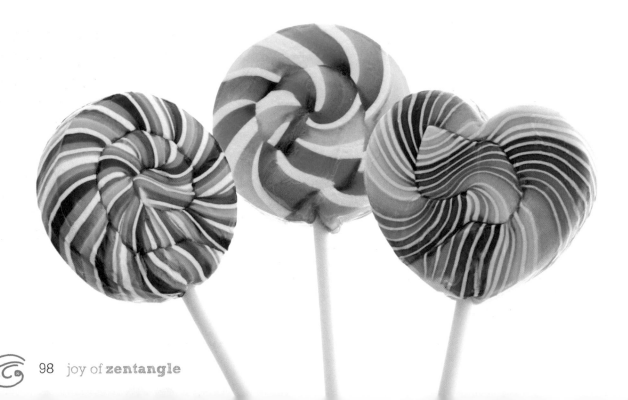

Marbles

Tangle by Suzanne McNeill, CZT.

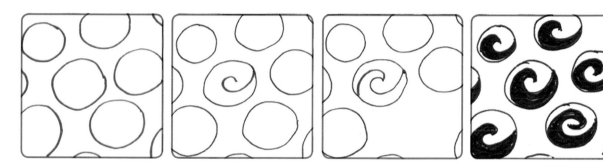

Zentangle Inspiration

I have been a very reluctant flier for many years. When our family moved from Anchorage, Alaska, to Tidewater, Virginia, we had to fly. I was not at all happy about this and had to take the maximum dose of an anxiety medication. When I was conscious, I was miserable with intense anxiety. Last year, my husband announced his company retreat would be in Faro, Portugal. How could I turn that down? I had to board the plane to Portugal by myself and meet my husband. As I settled in for my first international flight, I came equipped with a Japanese-style (accordion) journal and a handful of 005 Micron pens. When we were flying over the Atlantic, I started to feel quite anxious. I opened up my new journal and started to chronicle my transatlantic journey through the use of Zentangle. I loved it. I always felt good when I tangled. I was determined to make the trip without any medication, so instead, I used Zentangle as a means of relaxation and a point of focus. It was wonderful. I put my pen to the paper and took a deep breath and just let myself go. I felt wonderful and relaxed. It was amazing. Each stroke of the pen was an opportunity to go with the flow and create beautiful art work.

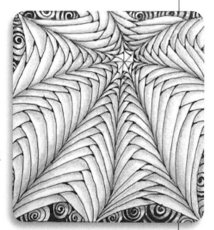

We are traveling to Scotland next month, and guess what is going to accompany me? Yep: a handful of Micron pens and a new journal for my next transatlantic trip. I love it!

—Brinn McFetridge, CZT

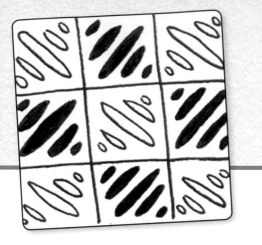

Matt

Tangle by Peggy Shafer.

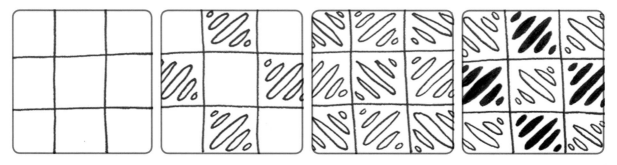

Zentangle Inspiration

Zentangle came into my life one Saturday morning when I took an introductory class. I tell my students, "I fell in love that day, and it's been getting better ever since." I fell in love with the idea that I didn't have to be perfect or even terribly artistic to be creative and centered. I fell in love with the process of manifesting art "one stroke at a time" with the rapid results that truly bubbled up joy in me.

As a CZT, I have designed and delivered introductory and advanced classes, with my latest love being "In the Zendala Zone." Using Zendala templates and a concentration process seems to bring people quickly into a deep focus in a way that triggers a centered serenity. I've found myself easily shifting my state of being from chaos to coherence and notice that thoughts clarify and emotions smooth out so that ideas surface to solve problems, meet new challenges, or that stress simply vanishes. Just yesterday, I was puzzled with coming up with the best way to deliver some difficult feedback to a coworker, so I took a fifteen-minute Zentangle break, and at the end I was calm and clear about what I had to say—a good use of the Zendala Zone!

—Karen Kathryn Keefe, CZT

Melody

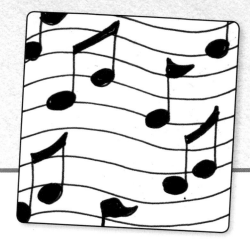

Zentangle-inspired pattern by Suzanne McNeill, CZT.

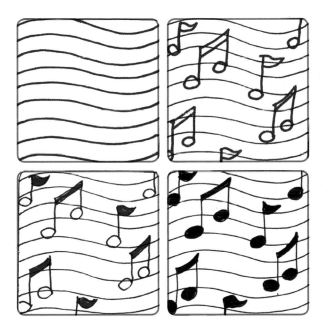

Mixed Signals

Tangle by Suzanne McNeill, CZT.

Mumsy

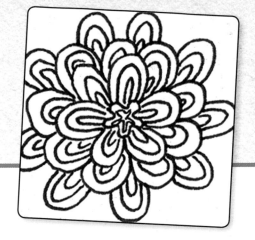

Tangle by Sandy Steen Bartholomew, CZT.

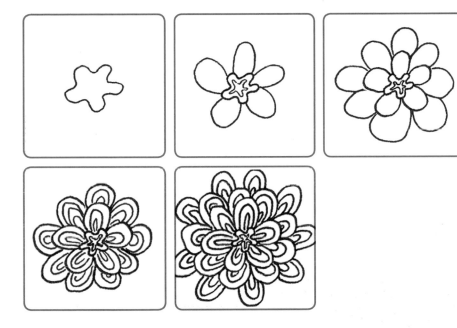

If you're looking for shapes to tangle in, pick up a coloring book and fill the blank drawings with tangles. You can also tangle in stamp and stencil shapes.

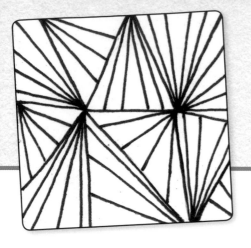

Munchin

Tangle by Molly Hollibaugh.

 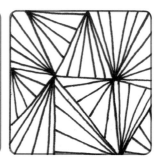

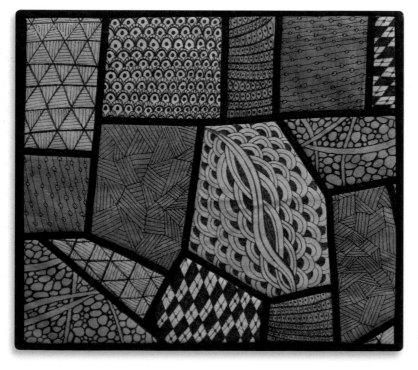

Zentangle Crazy Quilt
by Gail Ellspermann.

Nipa

Tangle by Rick Roberts and Maria Thomas.

Zentangle Inspiration

Having been an aficionado of the lettering arts and calligraphy for twenty-five years, I have always specialized in the drawn letterform. However, over the years, I rarely have made finished art.

I have found a deeper and more resonant sense of meaning and accomplishment when integrating drawn letterform into my ZIAs. The work I have been doing is a culmination of years of studying, drawing, and lettering.

I needed some portable art to carry around, and I needed something to help me calm down. The process of drawing patterns and integrating them with letters was the thing I had been waiting for. I have been able to use my own practice as a way to relax and tune out the noise, but also to do work I am proud of and can share with others.

In the past year, I have been teaching workshops for lettering artists. I have also sold my work for the first time. I have realized that I CAN be a teacher, and I CAN call myself a lettering artist, after all these years.

—C.C. Sadler, CZT

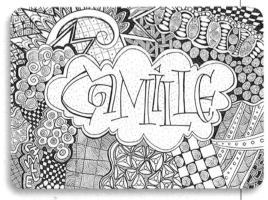

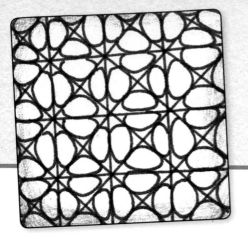

'Nzeppel

Tangle by Rick Roberts and Maria Thomas.

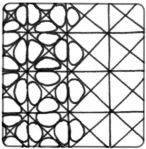

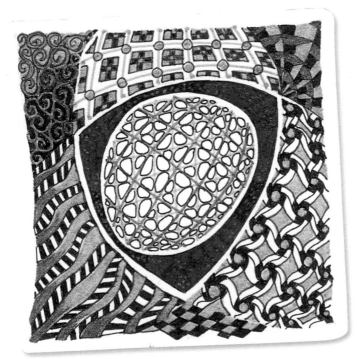

By Marie Browning, CZT.

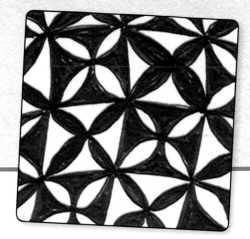

Orange Peel

Tangle by Suzanne McNeill, CZT.

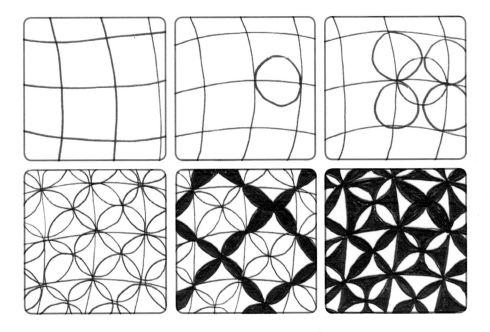

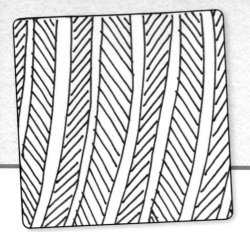

Papyrus

Tangle by Suzanne McNeill, CZT.

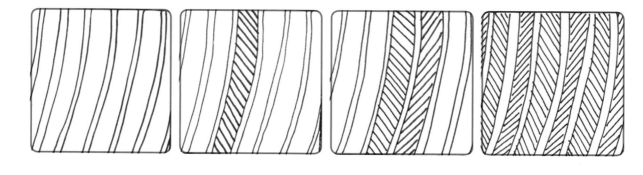

Zentangle in the Classroom

Draw a map of the country on a large piece of cardstock. For the string, use an outline of the states. Give each student a copy of the map. Each day, fill in a state with a tangle. This fun project helps students memorize the shape and position of the states on the map. At the end, every state will be filled with its own tangle.

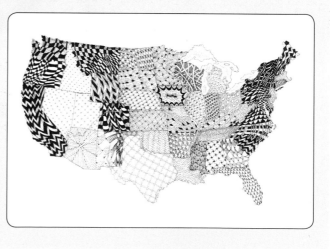

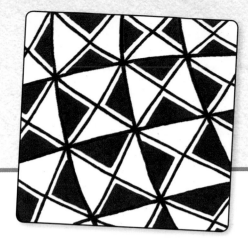

Pinwheels

Tangle by Suzanne McNeill, CZT.

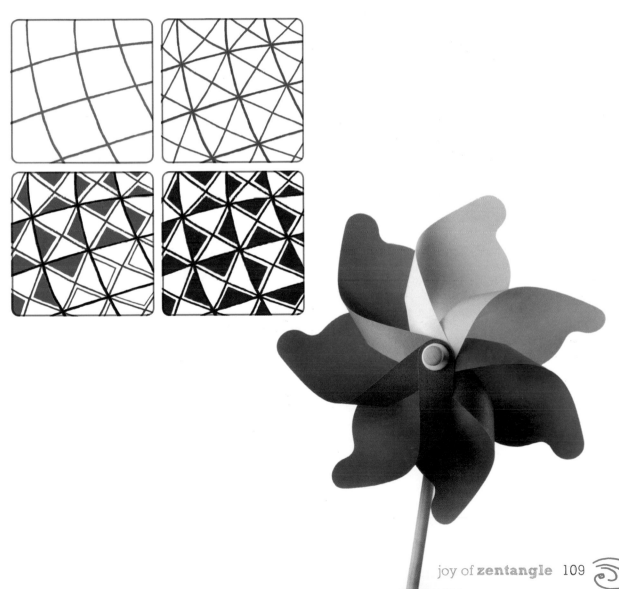

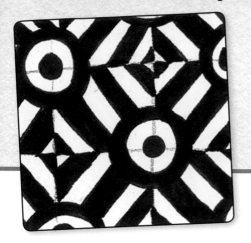

Popova

Tangle by Sandy Steen Bartholomew, CZT.

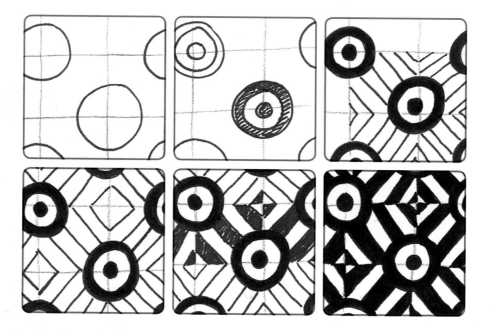

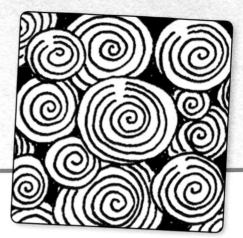

Printemps

Tangle by Rick Roberts and Maria Thomas.

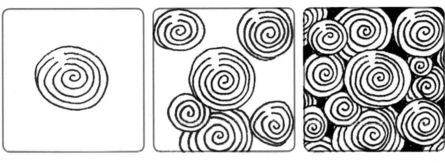

Symbolism: Spirals

This symbol of revitalizing life force expresses your growing knowledge. Let your creative spirit absorb new inspiration and express these insights with spiral shapes.

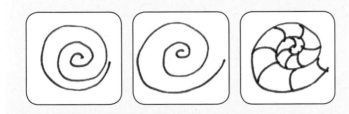

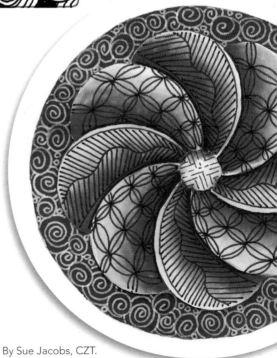

By Sue Jacobs, CZT.

Printemps Variation

A variation on a tangle by Rick Roberts and Maria Thomas.
Tangle by Suzanne McNeill, CZT.

Puff-O

Tangle by Sandy Steen Bartholomew, CZT.

Zentangle Inspiration

I learned about the Zentangle method through my work at Fox Chapel Publishing. With an MFA in Fiber and Mixed Media, I have an interest in many art forms, and I was able to observe and listen to comments about Zentangle art and Zentangle teaching methods at some of the trade shows I attended. I saw the Zentangle pieces done by my coworker, and was impressed by what she had created and listening to her story.

When my own father entered the hospital, I thought it was the right time to try Zentangle myself. A CZT friend suggested that there was a danger in using Zentangle at the hospital in that I would always associate it with my father's illness. In fact she was right; once he passed away, it took several months for me to begin to work with Zentangle again.

Now, I am impressed by what people can create with this tool. Time and again I have heard people say they are not artists, but when they learn to tangle, they walk away having created a wonderful work of art. I appreciate the gift that the Zentangle method gives that allows all types and ages of people to create and develop a voice that many did not know they even had.

For me, it has brought a great sense of satisfaction and enjoyment. I look at what I have done with pride and with great anticipation of learning new tangles and techniques. Zentangle has lived up to its name and I am fortunate to be able to continue and expand my knowledge of this fascinating art form.

—Judith McCabe, MFA, CZT

Purlbox

Tangle by Sandy Steen Bartholomew, CZT.

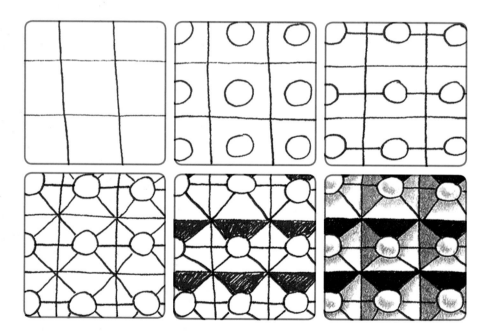

Pyramids

Tangle by Suzanne McNeill, CZT.

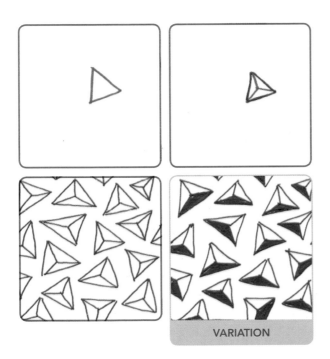

VARIATION

Queen's Crown

Tangle by Suzanne McNeill, CZT.

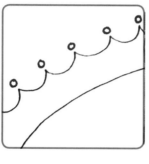
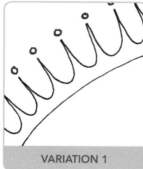

VARIATION 1

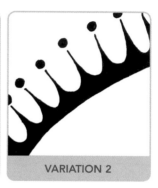

VARIATION 2

Divide your paper into sixteen squares. Leave the top left square empty. Put a basic tangle into each of the top three squares and three tangles you use a lot (or never!) into the three squares along the left edge. Now combine each row and column to create new tangles. Zentangle exercise by Sandy Steen Bartholomew, CZT.

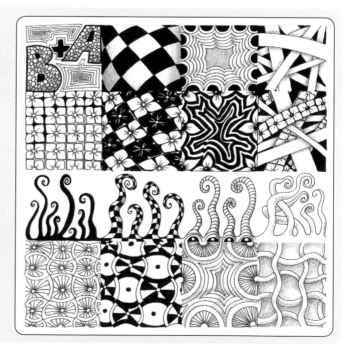

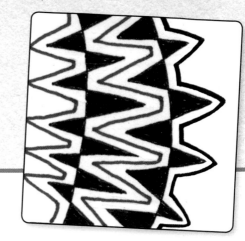

Rain Variation

A variation on a tangle by Rick Roberts and Maria Thomas.
Tangle by Suzanne McNeill, CZT.

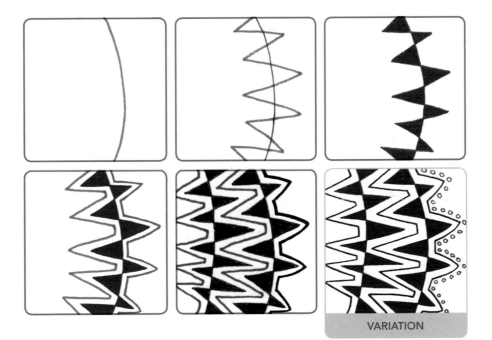

VARIATION

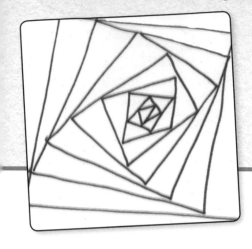

Rick's Paradox

Tangle by Rick Roberts and Maria Thomas.

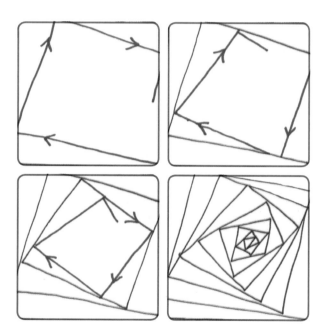

Ripple

Tangle by Sandy Steen Bartholomew, CZT.

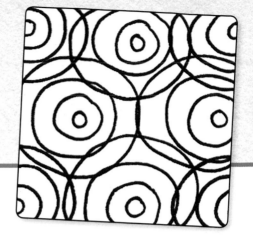

Symbolism: Circle of Protection

From the circle of a mother's protective embrace to round war shields, man has long associated safety with circles. Circular amulets guard man from disease and attack. Learning from herds of animals, nomadic groups arranged their camps in circles, placing the most vulnerable and valuable in the center. The circle of a mandala is often considered to be a circle of protection, whether you are facing an external threat from natural disaster or an emotional threat such as fear of failure.

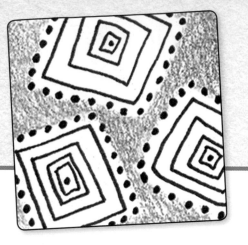

Sabi

Tangle by Sandy Steen Bartholomew, CZT.

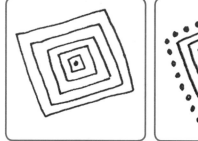
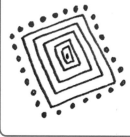
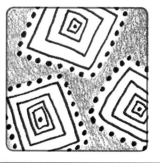

Zentangle Inspiration

On the "Theory of Zentangle" page on *www.zentangle.com*, it states: "There is no eraser in life and there is no eraser in Zentangle."

This is one aspect of the Zentangle method that made me interested in it in the first place. The idea that you can turn what might seem like a mistake into a new and beautiful pattern was revolutionary to me.

Unfortunately, I broke this very important and life changing rule of Zentangle. I took on an online challenge to create a tangle using only the patterns *Jonqal* and *Opus*. I had never used them before. The day I was working on the tangle was the one-year anniversary of my mom's death. As I worked, I found myself very disappointed with my attempt at creating the two new patterns. I thought the tangle was horrible, and I ripped it up.

A couple days later, I remembered the idea that there are no mistakes in Zentangle and I decided to redo the online challenge. The next day, another challenge was announced, focusing on the theme of hope. The tile I created for that challenge is now my favorite. After a moment of doubt, I had proven to myself that I could sit down and try again. I could "Hope" in something new arising out of something that was thought of as a failure. My hope Zentangle is a powerful reminder to not let self-defeating thoughts or any other struggles keep me down. If I keep at it, keep trying, keep creating, I can indeed make something beautiful.

—John Yanchek

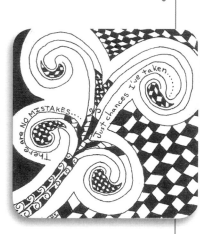

Sag

Tangle by Marie Browning, CZT.

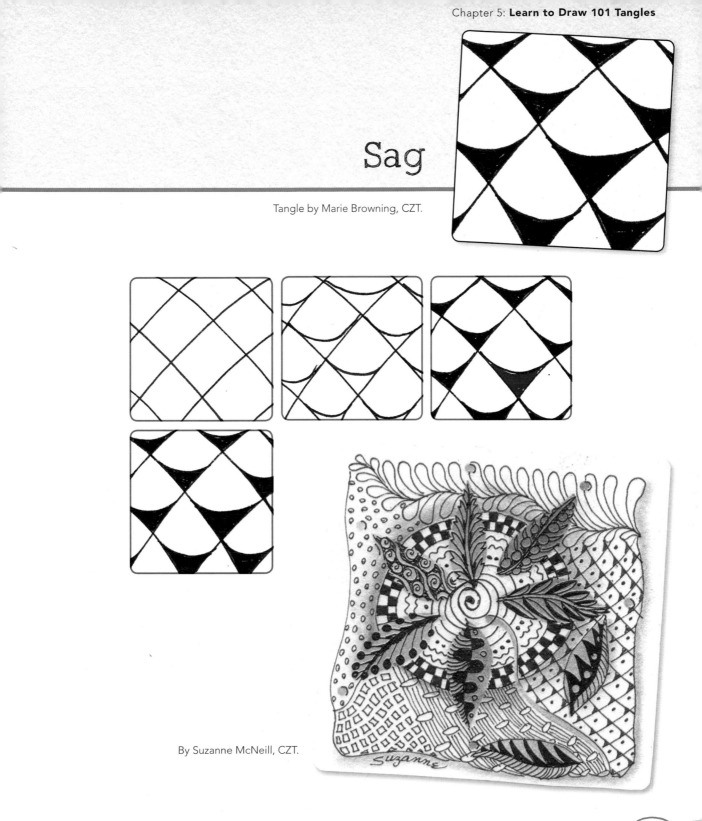

By Suzanne McNeill, CZT.

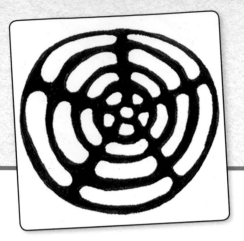

Slurp

Tangle by Sandy Steen Bartholomew, CZT.

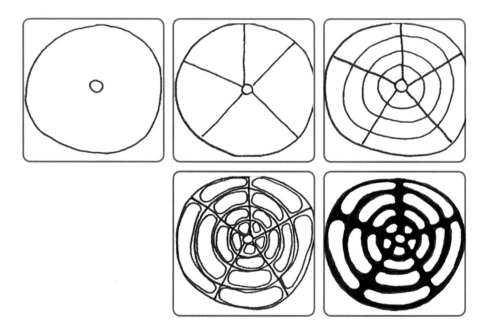

Soup Bowls

Tangle by Suzanne McNeill, CZT.

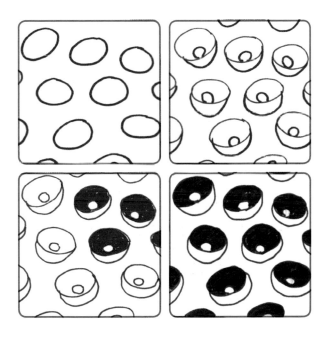

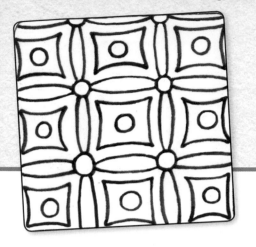

Square in Square

Tangle by Suzanne McNeill, CZT.

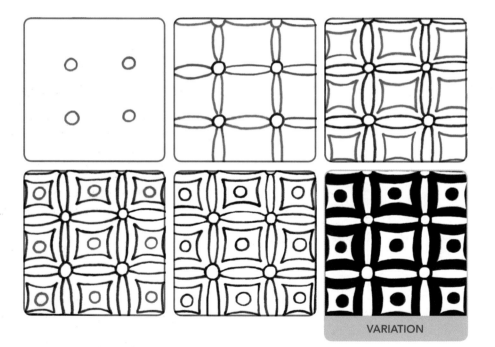

VARIATION

Starry Night

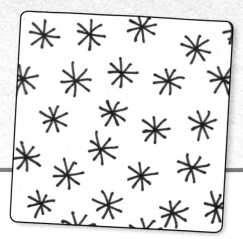

Tangle by Suzanne McNeill, CZT.

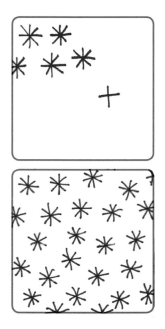

Zentangle Inspiration

I have long held that art is the best form of therapy, but it was not until I was introduced to the Zentangle method that I realized some art forms are better therapy than others.

My daughter was born with several health problems after a high-risk pregnancy, and the first year of her life was filled with operations and time spent in intensive care units.

My stress during that difficult time melted away with every tangle that I drew, and seemed to take on a life of its own. Symbols related to my ordeal began to form that brought my catharsis to a higher level. Hearts and birds began to pour onto the paper along with intricate tangles, ornamentation, and shading. Bob Marley's "Three Little Birds" had been my mantra throughout our hospital adventure, and it fused with my new love of Zentangle to create a truly powerful new feeling. Out of the darkness of that year, something bright and beautiful took shape, and brought me into the light as well. I believe that Zentangle came into my life for a reason, and I will be forever grateful for its existence.

—Sarah S. Nestheide

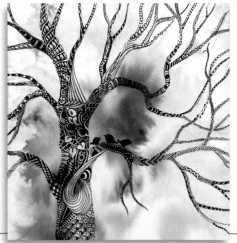

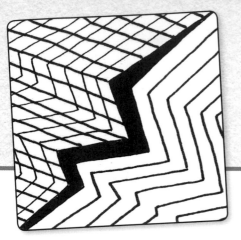

Static Variation

A variation on a tangle by Rick Roberts and Maria Thomas.
Tangle by Suzanne McNeill, CZT.

Symbolism: Lightning

Whether the bolt comes from Zeus or an exchange of energy between earth and sky, lightning is impressive in its power to dazzle and awe. Lightning is dynamic, so use it to express sudden illumination, sparks of insight, or dramatic change in your life.

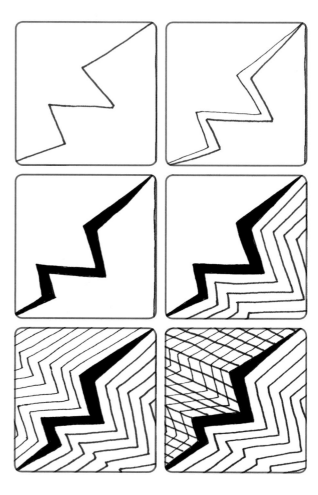

Stature

Tangle by Sandy Steen Bartholomew, CZT.

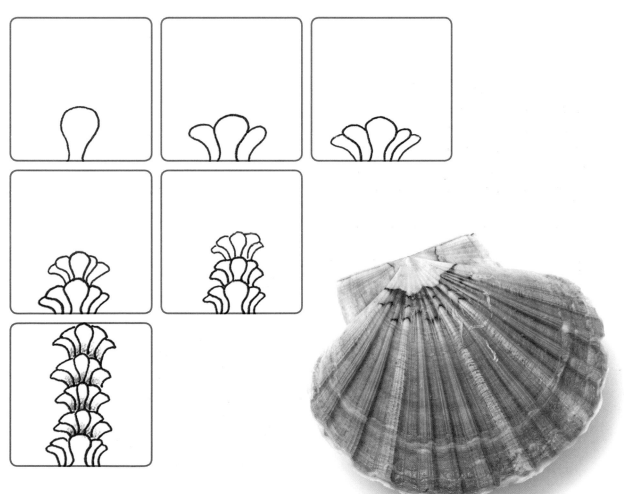

Swag

Tangle by Suzanne McNeill, CZT.

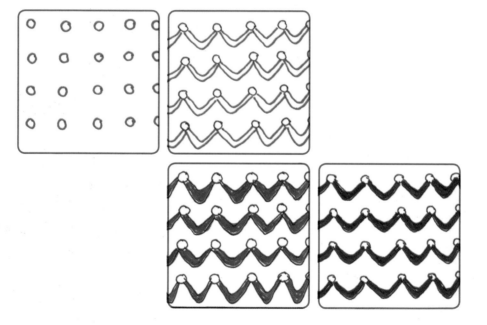

Tagh

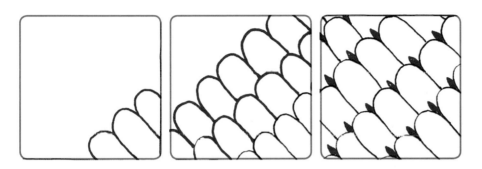

Tangle by Rick Roberts and Maria Thomas.

Zentangle Inspiration

When I was in high school, my art teacher said, "I'll give you a pass if you don't take another art class." It had a strong impact on me, and it was a long time before I would begin to create again.

Recently, I retired from a wonderful teaching career. The last twelve years of teaching, I was a school principal. It was exhausting, satisfying work that I loved. I happened upon Zentangle while looking for some interesting, free-motion quilting patterns. Within days, I was hooked. I tangled day and night. I found some tangles easy, some challenging, and others beyond me. Being a constant learner, I had to know more. Soon, I was in Providence, Rhode Island, learning more and more about this new art form.

I find Zentangle helps me breathe a little deeper. It calms my soul and gives me a satisfied feeling when I hold up my tile to see the amazing little piece of art that I have created. I love creating, and Zentangle has inspired my clay work as well. I am back, full circle, to creating, and as a CZT, it is Zentangle I am teaching now. It feels great.

—Sandra Chatelain, CZT

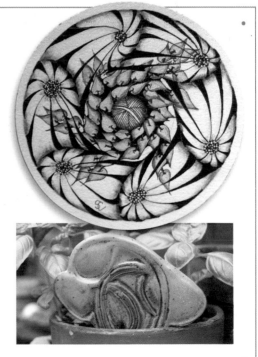

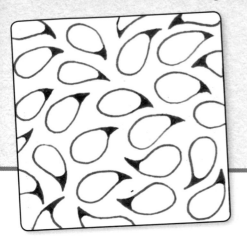

Teardrops

Tangle by Suzanne McNeill, CZT.

Symbolism: Water Droplets

Just as tears replenish your eyes, raindrops quench the dusty ground, making it possible for new growth to flourish. In the same manner, water rituals heal and cleanse the soul.

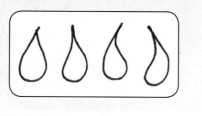

Tuffit

Tangle by Sandy Steen Bartholomew, CZT.

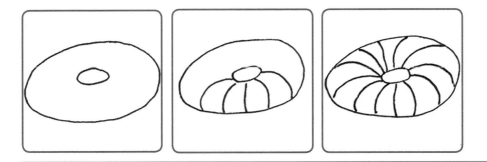

Zentangle Inspiration

In May, I was pregnant with my first child, Jeremiah. He was born, and God blessed my husband Eric and me with twenty minutes with our little guy. Life goes on, but sometimes we face things that seem to stop us in our tracks. The loss of my son did that to me. I was going through the motions of life, but wasn't really involved. I wasn't sleeping, and although I was still running my rubber stamp store, I really was just walking through life in a zombie-like state.

Zentangle was an up and coming "thing" that was getting very popular, so I thought I would bring a CZT in to teach at my store. I felt I needed to take the class myself for business purposes. I took that class and was the last student to leave! I loved what I did and was amazed that I was able to do it and the results looked GOOD! I was so excited, I immediately went home and looked up Zentangle online and spent the next four hours trying different patterns. I started creating Zentangle art each night before going to bed and found my secret for getting good rest! Needless to say, I was hooked!

As I was learning the Zentangle method, I started working on a piece in honor of my son Jeremiah. Each tangle I learned went into the piece as I learned it. It was a labor of love and helped me through the grieving process. Now that it is finished, I am having the piece framed and am giving it to my husband as a gift of love.

—Jennifer Van Pelt, CZT

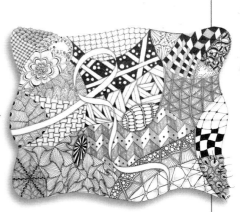

This piece of artwork was on display in an art gallery at the San Diego County Fair. It is one of Jennifer's most recent creations.

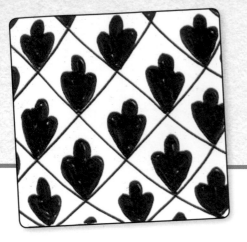

Tufted Leaves

Tangle by Suzanne McNeill, CZT.

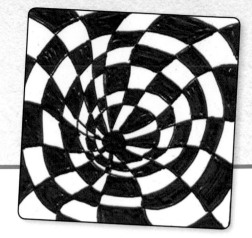

Twilight Zone

Tangle by Suzanne McNeill, CZT.

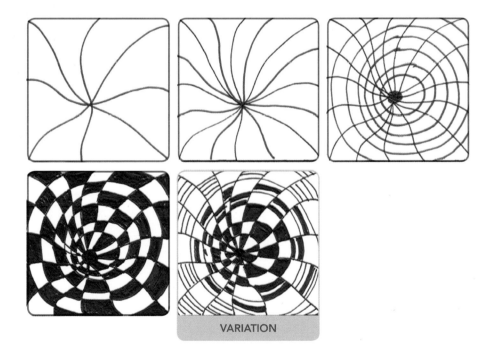

VARIATION

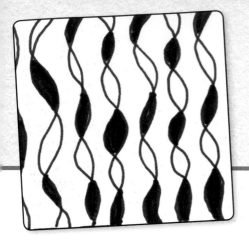

Twisted Ribbons

Tangle by Suzanne McNeill, CZT.

Zentangle Inspiration

Until recently, I had no idea how truly healing tangling could be. My mom, who suffers from multiple sclerosis and spends most of her days sitting in a chair, had a mild stroke a few months ago. While her motor skills weren't affected, her memory was. She no longer has the patience to read, do puzzles with grandkids, or even correspond with her friends, because her mind can no longer focus on one task for very long.

Seeing her frustration, I thought I would teach her how to tangle, because there is no need to finish a tile in one sitting, and there is no required outcome. She was reluctant at first, but when I reminded her how she used to write in squiggly shorthand (so we kids couldn't read her Christmas shopping lists), she took pen to paper. Starting with simple, repetitive shapes and lines to fill in her string, she had her first tile finished and was ready to start another. I put her tiles on the refrigerator so she can be reminded of something she can do from start to finish. We continue to have a "Zentangle evening" once a month, creating beautiful artwork and memories that I will cherish forever.

—Melissa Younger

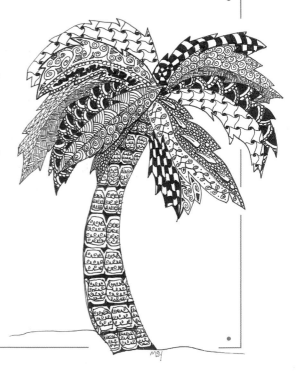

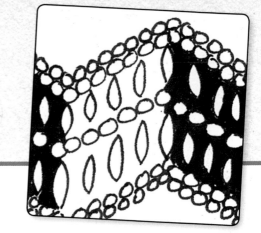

Unagi

Tangle by Sandy Steen Bartholomew, CZT.

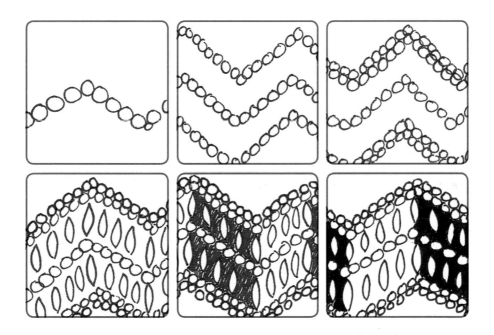

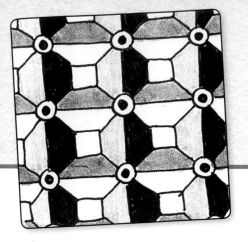

Vernazz

A variation on *Cubine*, a tangle by Rick Roberts and Maria Thomas. Tangle by Marie Browning, CZT.

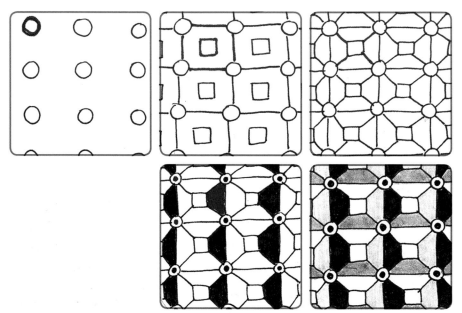

tip Use a white gel pen on black or dark paper to create stunning Zentangle art.

W2

Tangle by Rick Roberts and Maria Thomas.

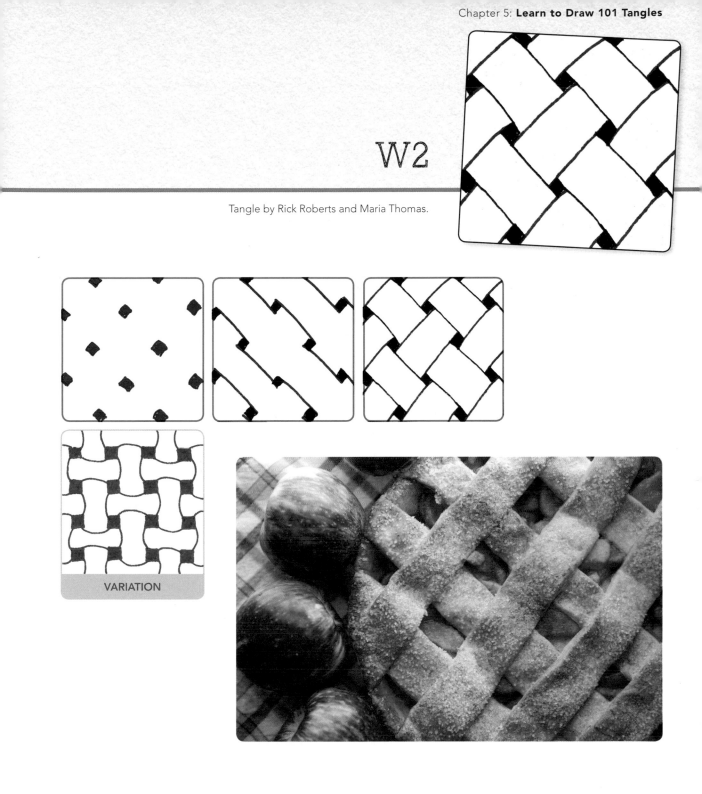

VARIATION

Wabi

Tangle by Sandy Steen Bartholomew, CZT.

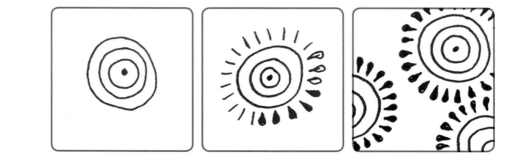

Zentangle Inspiration

The sudden loss of a dear friend left me with very little desire to be creative, but my job as a quilt pattern designer, author, fabric designer, and instructor relies on my being creative. A friend introduced me to Zentangle at a short class at my local quilt guild. After class was over, I drove directly to the office supply store to purchase some blank note cards (I was leaving the next morning for a seven-day cruise). I took a quick look at the Zentangle website and then left for my cruise. Each evening I found a quiet place and I created a new card. At the end of the cruise I had nine different Christmas cards. That was a new beginning for me.

As a quilt designer, I think, design, calculate, and quilt within graph-paper squares. I always had a complete plan before I ever started a project.

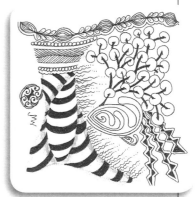

Learning the Zentangle process has taught me how to trust my own creative instincts and focus more on the joy of the creative process. I have stepped out of my little graph-paper box, and I am more open to letting each project grow without having a preconceived idea of the end product. I have always found inspiration in my surroundings, but now I even notice the smallest of details as possible tangles.

I look forward to exploring how to incorporate Zentangles into my quilting and sharing what I have learned with others.

—J. Michelle Watts, CZT

Waves

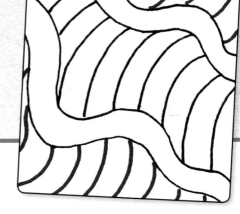

Tangle by Suzanne McNeill, CZT.

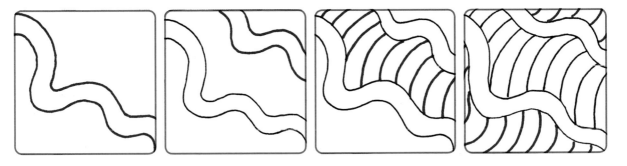

exercise

1. Start with a circle.
2. Divide it into equal sections.
3. Label each section with a concern or idea.
4. Start tangling around the circle.
5. Pay attention to your thoughts as you draw.
6. Jot each topic into a section as it pops into your head.
7. Keep tangling and writing in the thoughts as they pop up

Zentangle exercise by Sandy Steen Bartholomew, CZT.

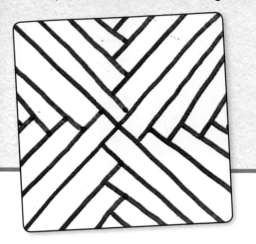

Weave

Tangle by Karenann Young.

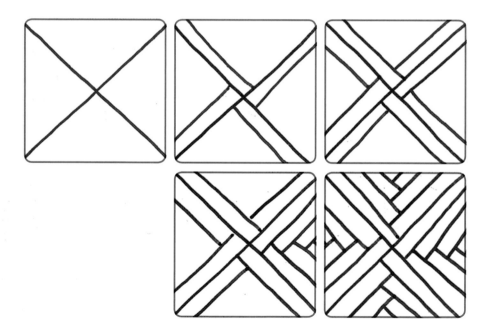

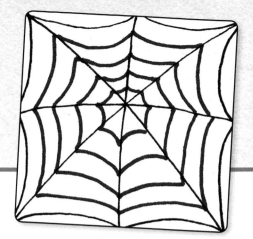

Web

Tangle by Suzanne McNeill, CZT.

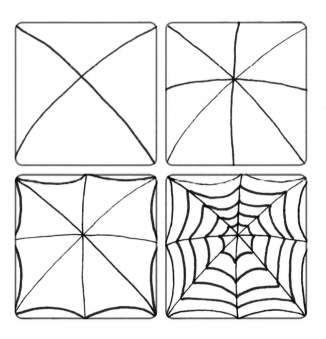

Symbolism: Webs

Spiders create homes by weaving and generating amazing and fragile webs. The beautiful web and the spider are associated with creation, life, and creativity.

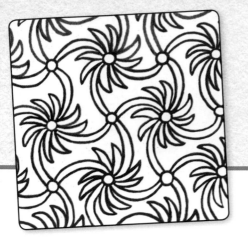

Whirls

A variation on *Huggins*. Tangle by Suzanne McNeill, CZT.

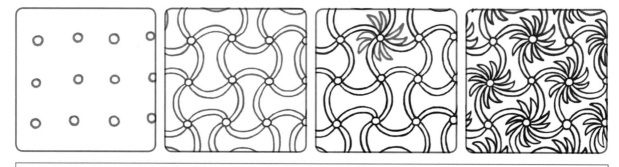

Zentangle Inspiration

In November, I was struggling with my mood, as I had been experiencing fertility problems, and it seemed I would not have the opportunity to become a mother.

I found the Zentangle method online one evening as I was researching ideas for activities for workshops to help people find health through art.

I started to make one, and suddenly started to feel better. It was like an epiphany! I felt better, not only because of the action of my hand on the paper, but also because I SAW Zentangle could be a way to give new oomph to my life. And it was like that! I experienced a new life…full of joy!

Making Zentangle art was my way to (pro)create a new Tina. That night, I was so excited and happy that I couldn't sleep! My positive mood influenced the people around me. I started to introduce the Zentangle method in my art therapy workshops, and it was a success.

Eventually, I decided to attend one of the seminars held by Maria and Rick to become a Certified Zentangle Teacher. Since my first encounter with Zentangle, I knew I had to go to a CZT seminar, so I planned to do so. The only thing not planned was the MIRACLE. Three months before my journey from Italy to the U.S., I got pregnant. The following year, my first baby was born, and I am the happiest mother!

Ciao from Italy.

—Tina Festa, CZT

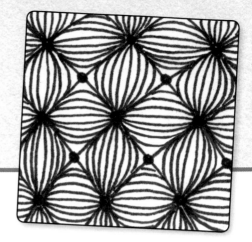

Yincut

Tangle by Rick Roberts and Maria Thomas.

ZIA by SherRee Coffman West.

5/15/09

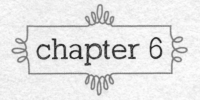

chapter 6

Traditional Zentangle Gallery

Zentangles are more than just drawings; they are meaningful pieces of art that can be restorative on many levels. The artwork produced by tangling will always contain a piece of you, whether it's reflected in the tangles you chose to use, the style in which you drew them, or the way you shaded the finished piece. You can keep your finished Zentangle art for yourself, or you can choose to share it with others—the gift of a Zentangle piece can be very inspiring.

This chapter celebrates the simplicity and beauty of traditional Zentangle art, which means all the pieces you will see here are done in black, white, and shades of gray. Take inspiration from these Zentangles—perhaps you will see a tangle you'd like to try yourself or a unique shading technique—and use them to develop some new pieces of art!

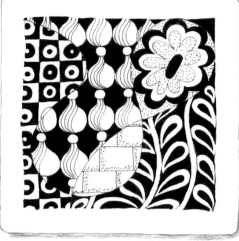

By Suzanne McNeill, CZT.

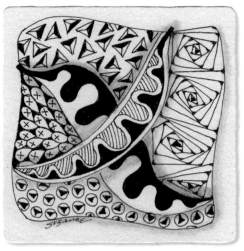

By Suzanne McNeill, CZT.

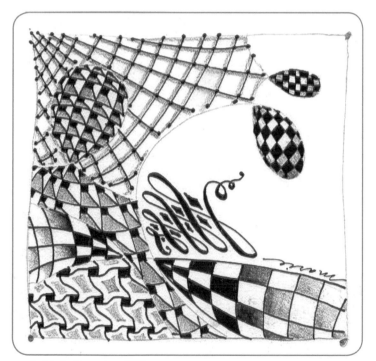

By Marie Browning, CZT.

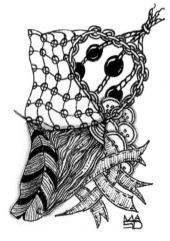

By MaryAnn Scheblein-
Dawson, CZT.

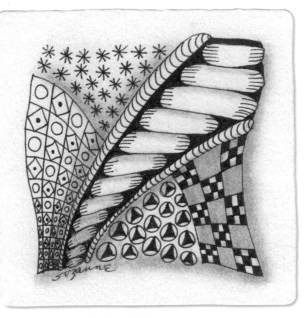

By Suzanne McNeill, CZT.

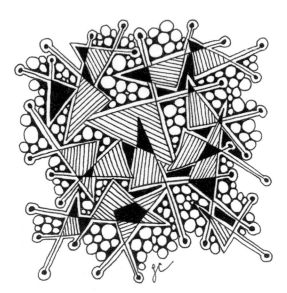

By Linda Cobb, CZT.

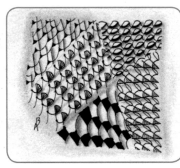

By Bette Abdu, CZT.

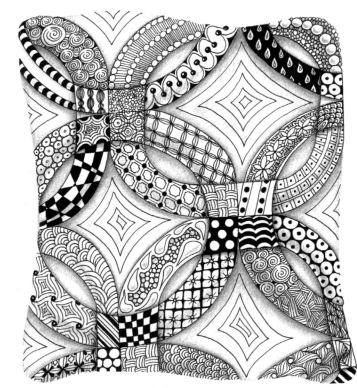

By Sandy Steen Bartholomew, CZT.

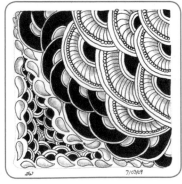

By SherRee Coffman West.

chapter 7

ZIA Gallery

Creating Zentangle art can bring you to a place of calm and focus, while allowing you to create something beautiful. Creating ZIAs also allows you to express yourself in a meaningful way in journals, on scrapbook pages, or simply on paper. ZIAs allow you to branch out even further with your creativity, while still providing the benefits of traditional tangling. This chapter highlights the unique shapes and colors ZIAs bring to traditional Zentangle art, and also provides some useful information on adding color to your designs. Use these ZIAs to inspire you as you continue to learn about the amazing impact the Zentangle method can have on your life. Visit *www.zentangle.com* to see even more Zentangle artwork.

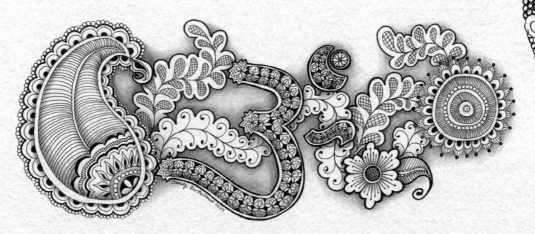

By Sandy Steen Bartholomew, CZT.

Adding Color

You can make vibrant ZIAs by coloring your
Zentangle art with a variety of mediums.
The following are directions for adding color
using dual brush markers, but you can also
use paints, watercolors, spray paint, pastels,
chalk, colored pencils or pens, and gel
pens to add a beautiful array of tones to
your work.

Coloring materials

Dual tip brush markers. Try using Tombow
Dual Brush Markers and a colorless blender
to color and shade.

> **tip**
>
> Let the first color dry before
> adding a second color on top.
> Do not overwork the coloring,
> as it may start to pill the paper.
> Using smooth watercolor paper
> prevents pilling.

Plastic blending palette. A 5½" x 8½"
(140 x 216mm) clear transparency sheet
taped to a piece of white paper works
well. The white paper will help you see the
colors clearly.

Paper tiles and squares. A 3½"
(89mm)-square Zentangle tile is preferable.
These tiles are made of smooth Italian art
paper that is easy to draw on and easy to
color (visit www.zentangle.com to purchase
tiles). This size is easy to carry, small enough
to allow you to complete a project in one
sitting, and is able to be combined in a
mosaic of tiles.

Direct coloring

Color areas on the tile with the dual brush
markers. Use the pen at full strength to add
color. Choose a large selection of colors
that include dark, medium, and light hues.

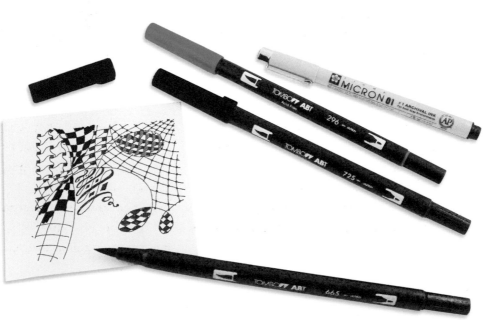

Indirect coloring

Stroke the colors onto your plastic palette using the brush tip until you have a 1"–2" (25–51mm) swatch of color on the palette. The color will not dry on the slick plastic surface.

Using the blender pen like a paintbrush, pick up the color from the palette with the brush point.

Start applying color to the tile where you want the darkest shades. Continue applying the color until the design is completely colored or no more color remains on the brush.

Work in small areas at a time and do not over-blend. Keep the pen on the paper while shading, and try to resist the temptation to go back and correct the middle of a blend.

This coloring method makes it easy to shade the color from dark to light and to mix colors by layering one color over another.

Brush blending

Using the brush tip, stroke the color from a dark marker onto your palette. Run a lighter colored dual brush marker through the color on the palette.

The colors will magically blend as you stroke the marker across the paper, and you can make several strokes with just one load of color.

The amount of color you pick up can vary to give you a variety of blended intensities. Use this technique when making the strokes in colored tangles.

To clean the brush tip, simply scribble the color out on a piece of scrap paper until it returns to the original color.

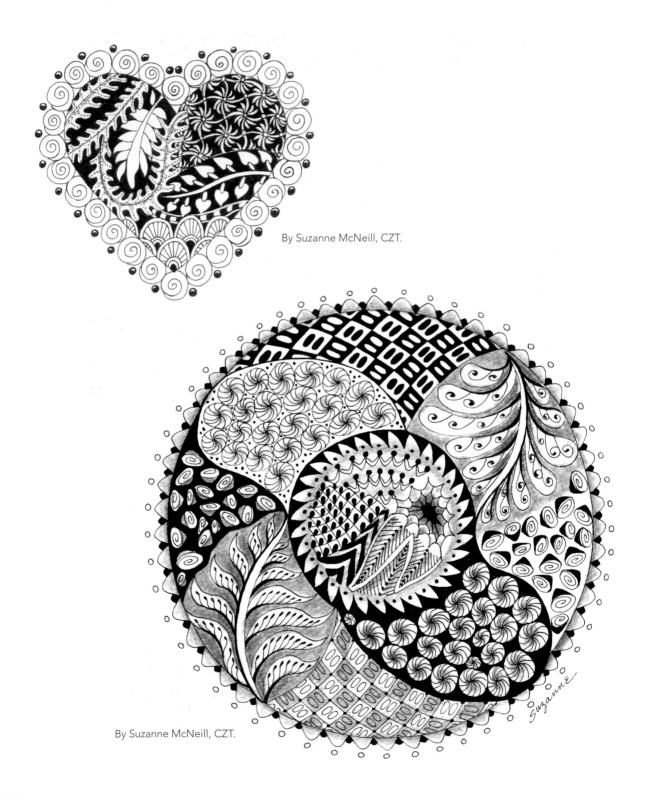

By Suzanne McNeill, CZT.

By Suzanne McNeill, CZT.

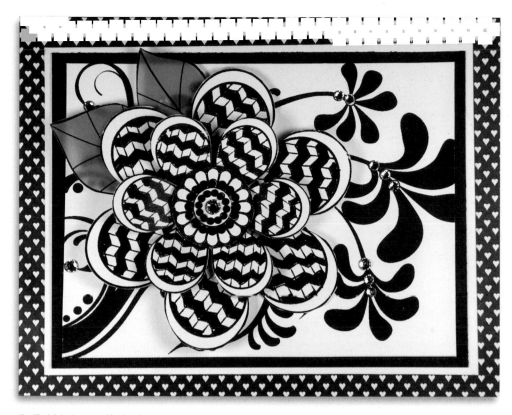

By Debbie Lagan, Kathy Jones,
and Mandy Boukus.

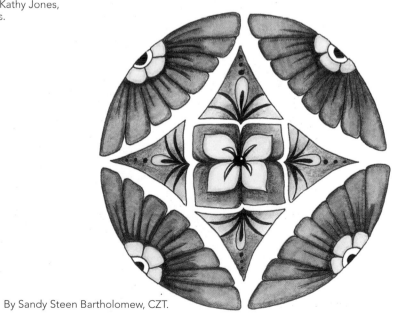

By Sandy Steen Bartholomew, CZT.

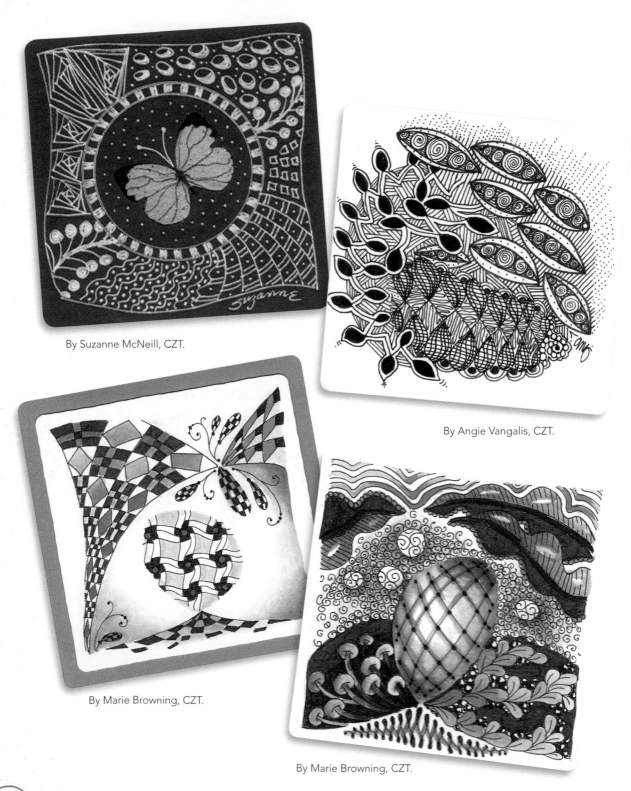

By Suzanne McNeill, CZT.

By Angie Vangalis, CZT.

By Marie Browning, CZT.

By Marie Browning, CZT.

chapter 8

Additional Applications

The Zentangle method is not meant to be restrictive, but rather to open your mind and engage you on multiple levels. You can therefore make Zentangle art whatever you want, and use it however you want. Traditional Zentangle pieces are done on paper, but you can also apply them to fabric, jewelry, leather, and clay, or use them to add a personal touch to a scrapbook page, card, or photo frame. Imagine how special it would be for family and friends to receive a holiday or get-well card from you with a Zentangle you created while thinking of those individuals? You can apply tangles to clothes, purses, and quilts. A Zentangle t-shirt could become an inspiring item to wear to a run/walk for breast cancer awareness. Use tangles on 3-D objects, for printmaking, and even on food. What better way to connect with your kids than by letting them decorate cookies or cupcakes with icing Zentangles? What this really boils down to is, you can use Zentangle however you want, in any medium you want. Let your imagination run wild!

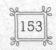

Jewelry

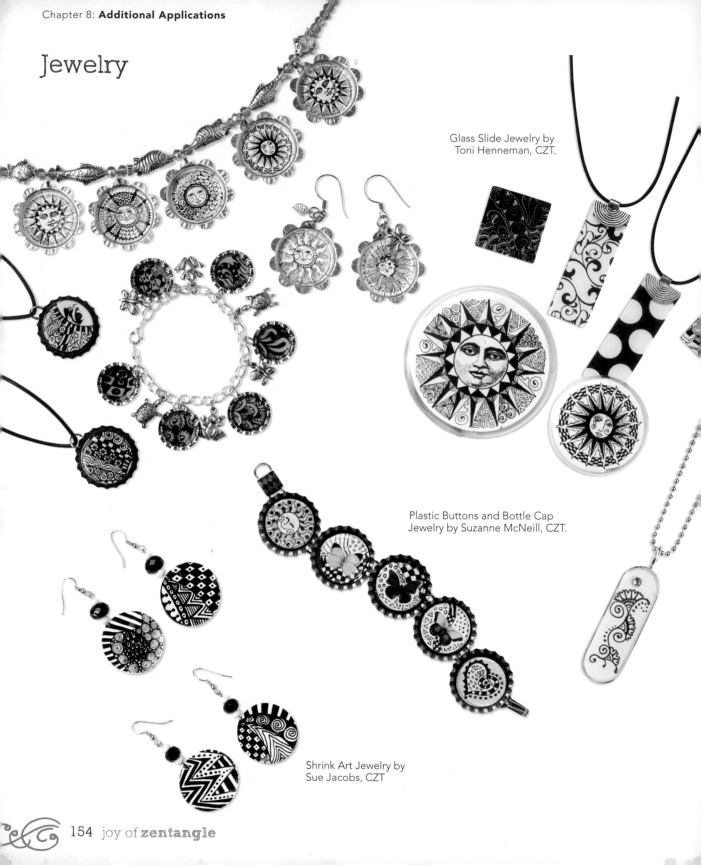

Glass Slide Jewelry by
Toni Henneman, CZT.

Plastic Buttons and Bottle Cap
Jewelry by Suzanne McNeill, CZT.

Shrink Art Jewelry by
Sue Jacobs, CZT

Paper Crafts

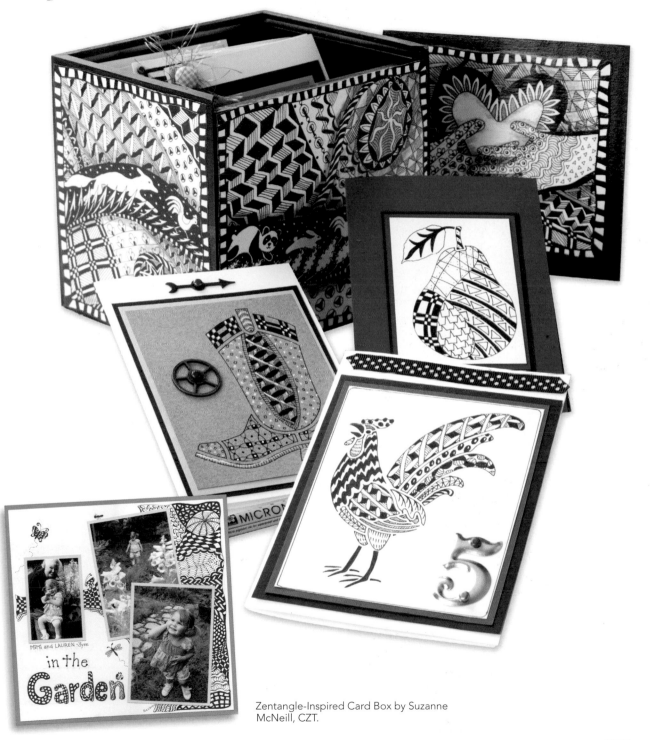

Zentangle-Inspired Card Box by Suzanne McNeill, CZT.

Printmaking

Etch a Zentangle design into a sturdy piece of foam and use it to create multiple prints of your Zentangle art.

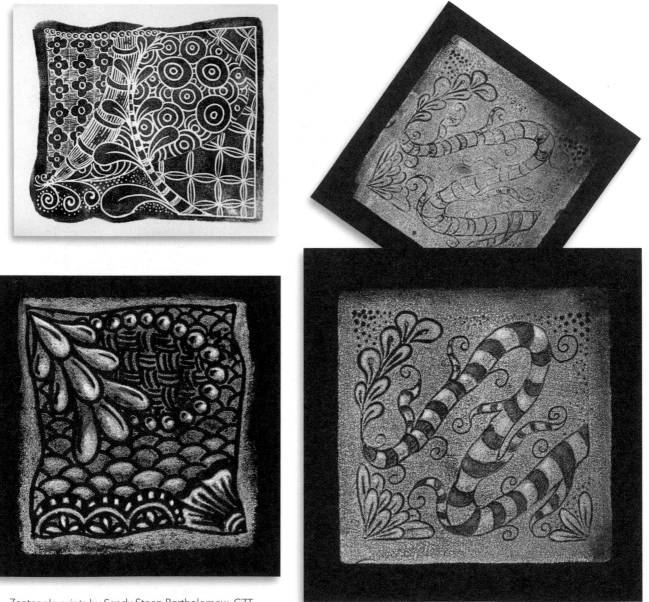

Zentangle prints by Sandy Steen Bartholomew, CZT.

3-D Objects

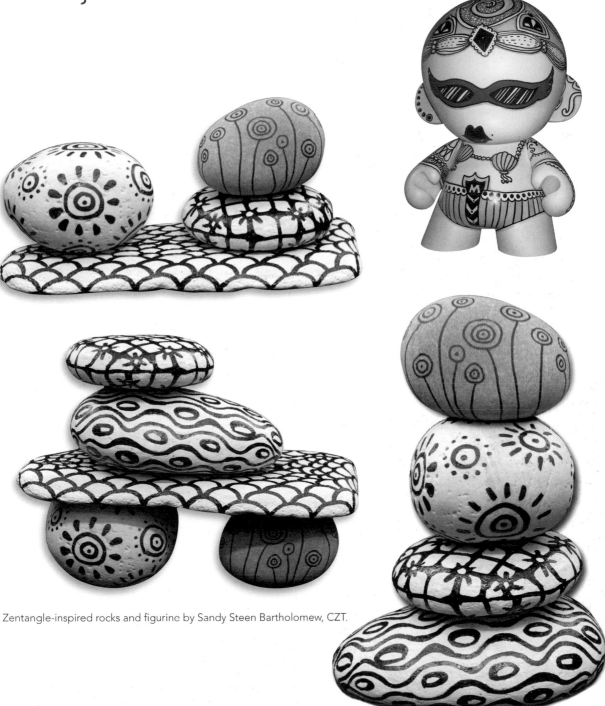

Zentangle-inspired rocks and figurine by Sandy Steen Bartholomew, CZT.

Fabric

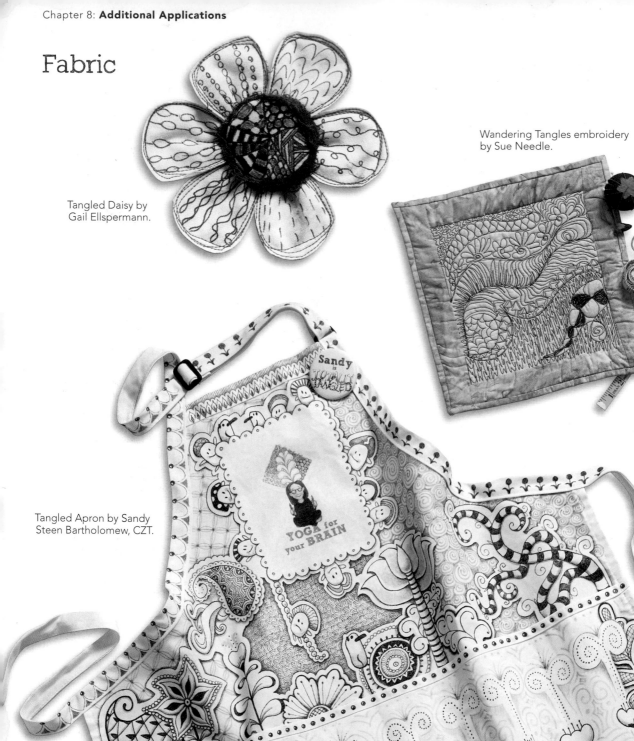

Tangled Daisy by
Gail Ellspermann.

Wandering Tangles embroidery
by Sue Needle.

Tangled Apron by Sandy
Steen Bartholomew, CZT.

158

Index

Acquisition editors: Peg Couch and Alan Giagnocavo **Cover and page designer:** Lindsay Hess **Layout designer:** Jason Deller
Cover photographer: Scott Kriner **Editor:** Katie Weeber **Proofreader:** Lynda Jo Runkle **Indexer:** Jay Kreider

With contributions by: Bette Abdu, CZT, Michele Beauchamp, CZT, Maya Bhatt-Hardcastle, CZT, Mandy Boukus, Margaret Bremner, CZT, Marie Browning, CZT, Jill Buckley, Sandra Chatelain, CZT, Linda Cobb, CZT, Kristi Parker Van Doren, Marta Drennon, CZT, Gail Ellspermann, Cindy Fahs, CZT, Tina Festa, CZT, Carol Bailey Floyd, CZT, Lois Henderson, Toni Henneman, CZT, Sarah Higgins, CZT, Sue Jacobs, CZT, Kathy Jones, Karen Kathryn Keefe, CZT, Debbie Lagan, Lynda Leeper, Cris Letourneau, CZT, Judith McCabe, MFA, CZT, Brinn McFetridge, CZT, Sue Needle, Sarah S. Nestheide, Carole Ohl, CZT, Jennifer Van Pelt, Kathy S. Redmond, CZT, C. C. Sadler, CZT, MaryAnn Scheblein-Dawson, CZT, Peggy Shafer, Cindy Shepard, CZT, Joanna Campbell Slan, Lisa Stearns, Sandra K. Strait, Dedra True-Scheib, CZT, Angie Vangalis, CZT, J. Michelle Watts, CZT, SherRee Coffman West, John Yanchek, Karenann Young, Melissa Younger, Meredith L. Yuhas, PhD, LPC, NCC, ACS, CZT, Renee Zarate, CZT

More Zentangle Books from Design Originals

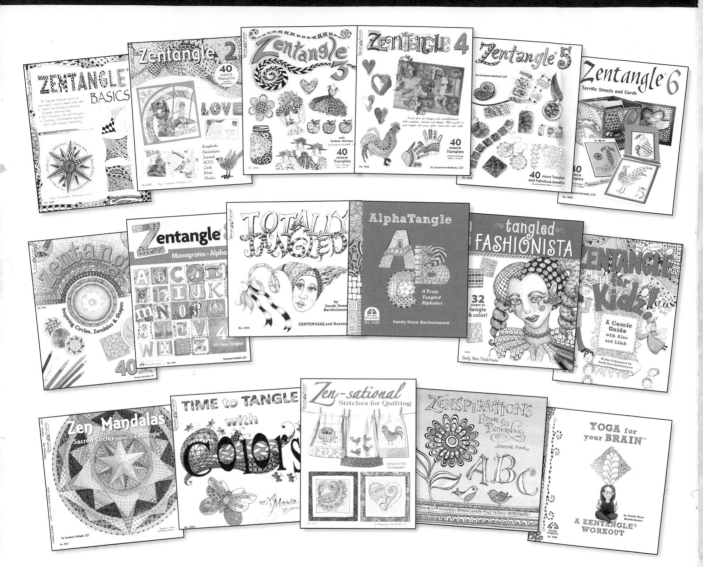

Zentangle Basics
DO3450 **$8.99**

Zentangle 2
DO3452 **$8.99**

Zentangle 3
DO3454 **$8.99**

Zentangle 4
DO 3456 **$8.99**

Zentangle 5
DO3459 **$8.99**

Zentangle 6
DO3462 **$8.99**

Zentangle 7
DO3484 **$8.99**

Zentangle 8
DO3485 **$8.99**

Totally Tangled
DO5360 **$16.99**

Alpha Tangle
DO3460 **$9.99**

Tangled Fashionista
DO3492 **$9.99**

Zentangle for Kidz!
DO3463 **$8.99**

Zen Mandalas
DO5367 **$16.99**

**Time to Tangle
with Colors**
DO5362 **$16.99**

**Zen-sational Stitches
for Quilting**
DO5377 **$18.99**

Zenspirations
DO5370 **$8.99**

Yoga for Your Brain
DO5369 **$16.99**